TO PAINT AND PRAY
The Art and Life of
William R. Hollingsworth, Jr.

Robin C. Dietrick

J. Richard Gruber, Ph.D.

MISSISSIPPI MUSEUM *of* ART
Jackson

This project is supported by ADAMS AND REESE LLP

To Paint and Pray is published in conjunction with the exhibition *To Paint and Pray: The Art and Life of William R. Hollingsworth, Jr.*, September 22, 2012 through January 13, 2013 at the Mississippi Museum of Art, curated by Robin C. Dietrick, assisted by Amber Schneider.

The Mississippi Museum of Art and its programs are sponsored in part by the city of Jackson and the Jackson Convention & Visitors Bureau. Support is also provided in part by funding from the Mississippi Arts Commission, a state agency, and by the National Endowment for the Arts, a federal agency.

Library of Congress Cataloging-in-Publication Data

Dietrick, Robin C., 1978-
 To paint and pray : the art and life of William R. Hollingsworth, Jr. /
Robin C. Dietrick, J. Richard Gruber, Ph.D.
 pages cm
 Includes index.
 Published in conjunction with the exhibition To Paint and Pray: The Art and Life of William R. Hollingsworth, Jr., September 22, 2012 through January 13, 2013 at the Mississippi Museum of Art.
 Includes bibliographical references.
 ISBN 978-1-887422-21-5
1. Hollingsworth, William R. (William Robert), 1910-1944--Exhibitions.
2. Mississippi--In art--Exhibitions. I. Gruber, J. Richard. II.
Hollingsworth, William R. (William Robert), 1910-1944. Works. Selections.
2012. III. Mississippi Museum of Art. IV. Title.
 N6537.H57A4 2012
 759.13--dc23
 [B]
 2012026569

Distributed by University Press of Mississippi
3825 Ridgewood Road, Jackson, MS 39211
www.upress.state.ms.us

Edited by Robin C. Dietrick.
Inventory (2009) of Hollingsworth artwork in MMA collection by Nientara Anderson.
Copyedited and indexed by Amanda R. Lyons.
Designed by Heidi Flynn Barnett, Flynn Design, Groovinby, Ltd.

Printed in Canada by Friesens

Mississippi Museum of Art

ISBN 978-1-887422-21-5

CONTENTS

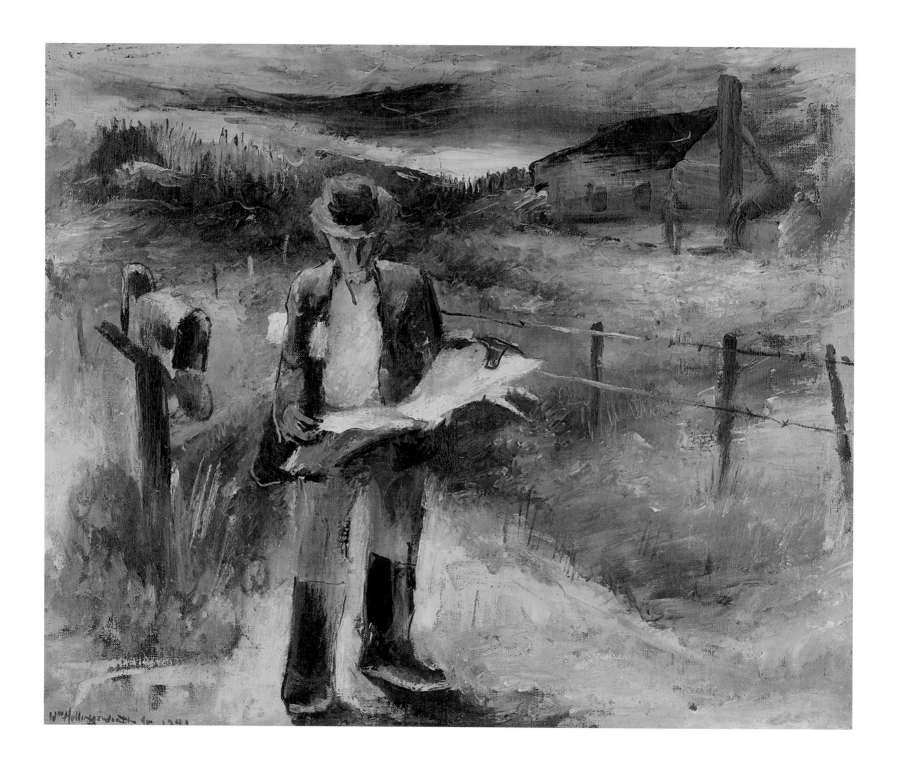

ACKNOWLEDGMENTS

In his too brief career, William Hollingsworth created a significant and compelling body of work that continues to move and inspire viewers of his art. He was a Mississippi son who elicited pride from his home state when he pursued his formal education and career in Chicago, and then returned home and found himself in the center of a particularly rich time in Mississippi art history. His work never disappoints and continues to find new admirers among art critics and the museum-going public alike. Responses to his work vary from wondrous and admiring to emotional and profound. The Mississippi Museum of Art is proud to house such a significant collection which documents our community so vividly and interprets it with such power.

This project is long overdue and has been extremely rewarding for the staff of the Museum. Led by curator Robin Dietrick, this exhibition and publication have enabled us to look anew at a body of work, conserve artworks, and identify the many diverse collections which hold Hollingsworth paintings. Robin researched the painter's career with focus and energetic interest, and gathered stories, anecdotes, and remembrances as well as new connections and insights into the artist's work. Her colleagues Beth Batton, curator of the collection; Amber Schneider, registrar; and Elizabeth Williams, director of education all contributed to the body of information contained in this text.

Richard Gruber has been a long-time admirer of Hollingsworth, and his important essay placing the artist in context is certain to elevate the stature of this body of work to the level of examination it deserves. Designer Heidi Barnett, together with editor Robin Dietrick and copyeditor Amanda Lyons, skillfully and sensitively incorporated the many threads and themes of the paintings into a powerfully presented publication that contributes to the canon of scholarship about Hollingsworth.

There are many people in our region who have emotional connections to this work and this artist. From the artist's son, William R. Hollingsworth III and nephew Brice Oakley, to family friends such as Hunter Cole and John Gibson, to those who sat for portraits or purchased pieces early in his career, Hollingsworth assembled a loyal and devoted group of admirers who have added intensity and emotional texture to this examination. We are privileged to live among these paintings and pleased to offer a fresh look at one of Mississippi's most favored artists.

Betsy Bradley

Director

Mississippi Museum of Art

Jackson

The Countryman
January 1-2, 1941
oil on canvas
18 x 22 in.
1987.015

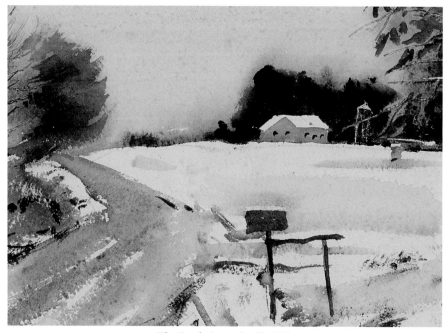

The Gentle Snow (detail), *1944*

"Well—to hope and hope and pray and paint and paint and paint and paint and pray."

–William R. Hollingsworth, Jr., January 2, 1941

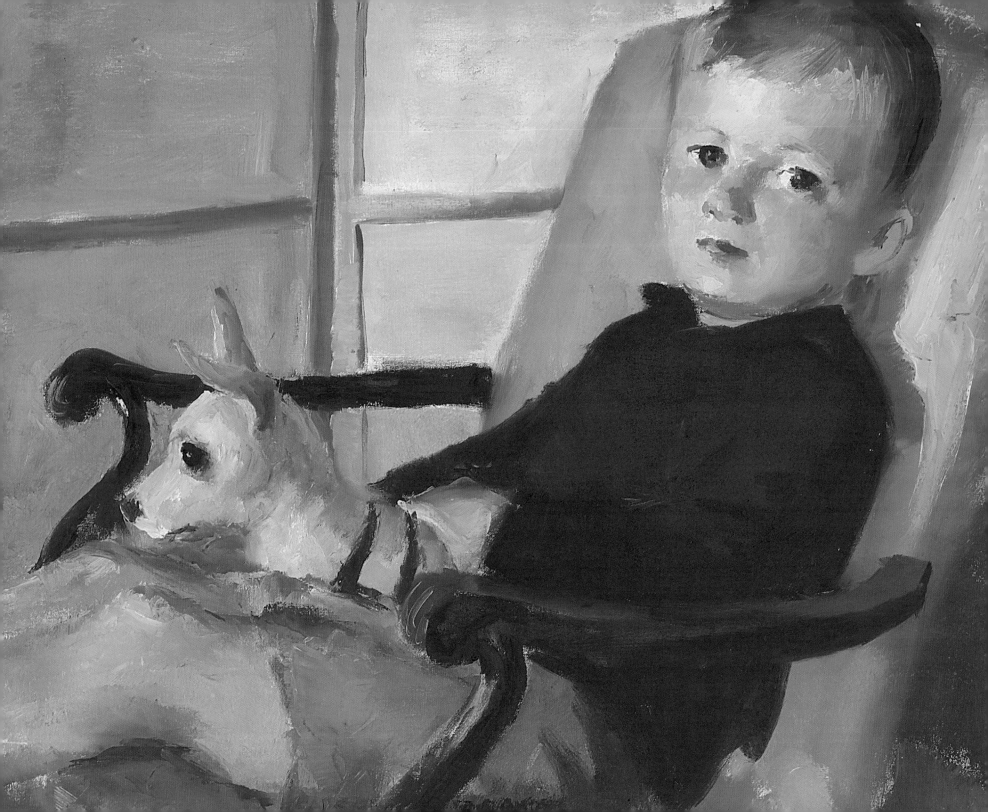

To Paint and Pray: The Art and Life of
William R. Hollingsworth, Jr.

Robin C. Dietrick

Billy and Boy
May 22, 1942
oil on canvas
20 x 24 in.
1987.025

William Robert Hollingsworth, Jr., March 1943.

There is a mystery surrounding William Hollingsworth unlike any other Mississippi artist. While much of his artwork focuses on himself and his family, his most steadfast fans know only surface details of his life and career. In fact, his closest friend, Jackson artist Karl Wolfe (1904–1984) stated, "even his most intimate friends hardly knew [him]."[1] **To Paint and Pray** *attempts to shed light on this intriguing early-twentieth century artist through an exploration of Hollingsworth's artwork from the 1930s and 1940s and a thorough examination of the artist's life and critically acclaimed career.*

Hollingsworth was a deeply emotional and sensitive human being, who had a never-ending drive to create artwork and to achieve national success as an artist. Not overtly religious (though he did attend church regularly), the artist's spirituality emerges through his writing and his artwork. He felt a connection with nature, often leaving downtown Jackson to sketch or paint outdoors. He expressed excitement or dismay as colors changed with the season, or the weather fluctuated. His anticipation is palpable as he wishes and hopes and prays for his paintings to do well with the juries reviewing them—acceptance led to elation; rejection led to devastation. Hollingsworth's life and career were intertwined and cannot be discussed separately.

Birth of the Artist: Growing Up in Jackson

William Robert Hollingsworth, Jr., was born on February 17, 1910, in his family's home at 754 North President Street in Jackson, Mississippi. Proud parents were William Robert Hollingsworth, Sr. (September 10, 1865–June 20, 1943), and his wife Willie Belle Vanzile Hollingsworth (June 6, 1874–December 9, 1910).[2] Already the parents of a thirteen-year-old girl named Isabel, young William's parents were older than average to have a newborn, father at forty-four and mother thirty-five. They had married in the bride's hometown of Vicksburg on March 24, 1896,[3] before moving to Chicago where Mr. Hollingsworth worked for the Rock Island Railroad.

In 1898 the Hollingsworths returned to their home state and lived in Jackson for nearly six years before purchasing in 1904 the home where William Jr. would be born. It was acquired from the Mississippi School for the Deaf, which had purchased the land from the Yerger family and operated in the family's mansion there from December 1, 1871, until a fire destroyed it on March 18, 1902. School leaders then constructed five houses in the main building's place, and the school occupied them from November 3, 1902, until March 13, 1904, when their new, permanent campus opened at 1448 West Capitol Street.[4] Willie Belle and William Hollingsworth, and their children, were the first and only family to live in the substantial home at 754 North President Street until it was demolished in early 1968. The four-bedroom home offered plenty of room for the growing family, and included a formal dining room, multiple living spaces, and four porches, two of which were on the second floor. One room off the screened porch at the back of the house eventually became the location of William Jr.'s studio.[5]

Hollingsworth family home at 754 North President Street, Jackson, 1910.

Central High School, Jackson. Photo © Gil Ford Photography.

Willie Belle passed away on December 9, 1910 when William was only ten months old. The baby was left to the care of his teenage sister and their father (known as Mr. H.), who provided for the small family with his job as a real estate agent. As such, Mr. H. counted the new Belhaven neighborhood among his projects. Hollingsworth, Sr., was also secretary at First Baptist Church, where he penned the history of the institution in 1936.

William Jr. began school at Jefferson Davis Grammar School, which was in the same block as his home, one street east. He then attended Central High School on West Street, less than a mile from home and which currently houses the Mississippi Department of Education. The mild-mannered student—whose quote under his senior portrait in the 1928 *Quadruplane* stated, "Everyone likes a good natured person"—grew his interest in art there.[6] As early as his freshman year in high school, William Hollingsworth, Jr., wished to pursue his artistic gift. He convinced his father to cover the $25 fee for a correspondence course in cartooning. These focused studies spurred his interest in cartooning and commercial illustration, and he exhibited enough ambition that in his senior year his father arranged for him to meet with acclaimed *Chicago Tribune* cartoonist Carey Orr (1890–1967). Hollingsworth and his father enjoyed a week-long trip to Chicago during which the young artist was able to share his drawings with the renowned cartoonist in person. Orr was supportive of Hollingsworth's intended career path and encouraged him to study English and history to bolster his existing artistic talent.[7] This advice influenced Hollingsworth's decision to attend college at the University of Mississippi (Ole Miss) in Oxford, to acquire a general education.

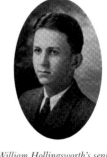

William Hollingsworth's senior portrait in Central High School's yearbook The Quadruplane, *1928.* Courtesy of Mississippi Department of Archives and History, Jackson.

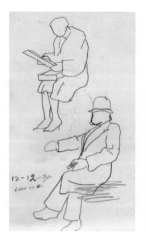

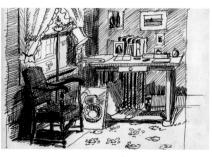

Cartoon by William Hollingsworth in the Ole Miss *yearbook, 1929.*
Courtesy of Mississippi Department of Archives and History, Jackson.

William Hollingsworth's portrait in the Ole Miss *yearbook, 1929.*
Courtesy of Mississippi Department of Archives and History, Jackson.

Life as an Art Student:
Ole Miss and the School of the Art Institute of Chicago

While pursuing basic studies at Ole Miss, Hollingsworth continued his involvement with art in an official capacity as the art editor for the *Ole Miss* yearbook. As such, he contributed a number of original drawings for the publication, like illustrations for advertisements and pictures that related to social life at college, including couples dancing and even someone spiking punch at a party. Hollingsworth, or "Hollie," as he had become known, was a pledge to the Delta Tau Delta fraternity at Ole Miss and enjoyed his own social outings that included sporting events. One memorable evening involved the excitement of a football game win that broke a decade-long losing streak against a rival school. Hollie's friend Tom Etheridge contributed an article to Jackson's *Clarion-Ledger* newspaper, which chronicled a seven to six win over Mississippi A & M (now Mississippi State University):

> This scribbler's boyhood friend, the late William R. Hollingsworth—related by many as the best artist Mississippi has produced—was among Ole Miss celebrants that wild afternoon. Years afterward, friend 'Hollie' loved to recall the black eye and bloody nose he suffered in helping to tear down the Aggie goal posts after Webb Burke's perfect placement. There was fighting on the gridiron, on the campus and even downtown but luckily no one was reported as critically injured.[8]

In a bold move twenty-year-old William Hollingsworth, who had never lived outside of Mississippi, left Ole Miss after two years of study. He enrolled in the School of the Art Institute of Chicago in 1930, with the intent of ultimately becoming a commercial artist. In his first year as a full-time art student, Hollingsworth lived about twelve miles from school at 509 North Grove Avenue in the Chicago suburb of Oak Park, Illinois,[9] less than a quarter-mile from Frank Lloyd Wright's home on Chicago Avenue. Public transportation like the elevated trains, or the 'L,' ran from Grant Park, where the Art Institute is located, to Oak Park as early as 1921.[10] Hollie used travel time to sketch people on the 'L.' While his 1930 sketchbook includes spontaneous sketches of locals, it also clearly betrays the serious artistic intentions of its owner with the inclusion of drawings of classical statues and notes taken in art history class.

Though he was in Chicago to pursue an avenue in commercial art, Hollingsworth had found a new passion by 1931, when he said the painting "bug bit me."[11] In 1932, he moved closer to school and the shores of Lake Michigan when he rented a room in a multi-floor brick building at 940 Ainslee. He set up a makeshift studio there with a desk by the window. His studies that year included the artist Honore Daumier (1808–1879) with whom there was a kinship because of Daumier's thousands of satirical prints on French politics or other current events, a precursor to the work of modern cartoonists. Hollingsworth's 1932 sketchbook also included figure studies, Chicago scenes, and various notes on color, with a quote attributed to artist Paul Gauguin (1848–1903) scribbled onto a page that reads, "How does that tree appear to you? Very green? Very well, then, use green, the greenest green on your palette. Find that tree is rather blue? Do not be afraid; paint it as blue as you can."

THE SCHOOL OF THE
ART INSTITUTE OF CHICAGO | DATE MAR 26 1934

Celia Jane Oakley, 1928.

William Robert Hollingsworth III, Moline, Illinois, June 9, 1934.

William Hollingsworth's class schedule at the School of the Art Institute of Chicago, March 26, 1934. Courtesy of Mississippi Department of Archives and History, Jackson.

Classmate Palmer Eide of Sioux Falls, South Dakota, became one of Hollingsworth's closest friends at art school. The two sketched each other, one drawing labeled "Polly" by the artist "Hollie," and they remained in contact via correspondence even after they finished their studies in Chicago. Fellow student Celia Jane Oakley (1912–1986), who studied and excelled in fashion design would, in a few years, become Hollingsworth's wife. Her father Robert Oakley was a physician, born in Illinois to Swedish immigrants. Gertrude Melvin Oakley, Jane's mother, was born in Wisconsin to a Minnesotan father and a Norwegian mother.[12] Jane and her younger brother Robert grew up in nearby Moline, Illinois, across the Mississippi River from Davenport, Iowa. Oakley and Hollingsworth married in Chicago on September 20, 1932, and they remained there to finish their studies at the Art Institute.[13] The very next year, the young couple welcomed their first and only child William Robert Hollingsworth III. The youngest Hollingsworth was born one month early, at 8:32 p.m. on July 6, 1933, at Moline Public Hospital,[14] and he immediately became the center of attention and subject of many works of art by his father.

In 1933, William Hollingsworth took classes in lithography under the tutelage of Francis Chapin (1899–1965) and David McCosh (1903–1981). The class introduced the artist to another of his favorite mediums and to a skill that would be useful to a commercial artist. During the year 1933, Hollingsworth produced a number of lithographs, many of which illustrate daily activities in Chicago—a boxing match, people swimming, a blossoming courtship at a soda fountain, men congregating at a bar or playing pool, and many others. To his dismay, Hollingsworth was unable to continue

lithography after returning to Mississippi in 1934. He spoke to reporter Martha Harrison of his desire to resume printmaking in 1938, and she explained, "He would like to do more lithography, 'one of the best of the graphic arts,' preferring it to etching because it involves more painting. He has exhibited some of his lithographs here, done while in Chicago, but he can't return to them for some time, since they require a 'regular laboratory.'"[15] He did, however, receive recognition in Mississippi for his lithographs in an exhibition at Belhaven College in Jackson, sponsored by the school's Cary Art Club and held in Fitzhugh Hall. William Hollingsworth began to make a name for himself in Jackson, even before his return to the state. In addition to the show of his lithographs at Belhaven, in April 1933, he was included in the Amateur Show at the Municipal Art Gallery, organized by the Mississippi Art Association. There, he received first prize in the print division and second prize for an oil painting.[16]

The following spring, Hollingsworth took courses in life drawing, still life, and the advanced art history survey class, occupying all of his weekdays. At the close of that semester, William Hollingsworth completed his studies at the School of the Art Institute of Chicago. A career as an artist seemed unlikely, as Martha Harrison explains, "At conclusion, in 1934, of his four years at the art institute, he made a 'grand and glorious tour of commercial art galleries,' found that those not already closed were on the verge of closing, and came back to Jackson where he and Jane, whom he'd married two years before, could live, because a job awaited on the FERA."[17] In late summer of 1934, the young family moved into a small brick house at 763 Lorraine Street in the city where Hollie was born.

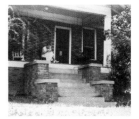

Pick-up
1933
lithograph
12.5 x 9.5 in.
1987.183

Hollingsworth home at 763 Lorraine Street, Jackson, August 1934.

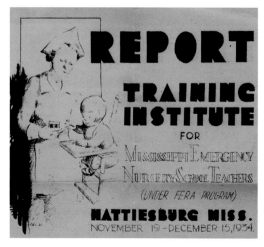

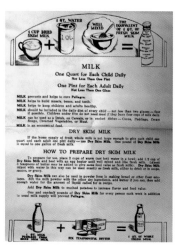

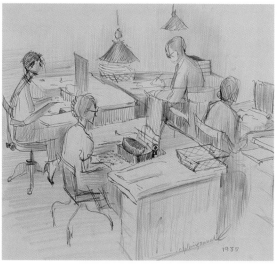

Cover design by William Hollingsworth for Mississippi Emergency Nursery School Teachers training institute booklet, 1934.

Illustrations by William Hollingsworth on the preparation of dry milk, 1934.

Courtesy of Mississippi Department of Archives and History, Jackson.

Office F.E.R.A. in Tower Building
1935
colored pencil and ink on paper
8.5 x 11 in. (sight)
1987.058

Emerging Artist:
Return to Jackson, Government Work, and Early Successes

The Federal Emergency Relief Administration (FERA) offered Hollingsworth and many others seeking employment, a small, but steady income that was greatly valued during the harsh economic times of the 1930s. The FERA office was located in the Tower Building (now known as the Standard Life Building), which was built in 1929 at the northwest corner of Roach and Pearl streets.

There he kept a regular routine of office work and had enough spare time to continue pursuing an artistic career. He reiterated this benefit to Martha Harrison, who wrote, "…he's followed a routine of clock-punching, day-time office work, painting at nights and on week-ends. It's nice for an artist to work for the government, he believes, because there are so many holidays. And they are, rather important."[18] He was even able to use his artistic skills at work, designing and illustrating brochures and leaflets for the government. One example is his 1934 illustration for the cover of a booklet for Mississippi Emergency Nursery School Teachers. Another was a leaflet where he illustrated the preparation of dry milk, along with recommended daily consumption for children and adults. Certain other sketches, however, indicate that he occasionally sketched from his desk in the large office he shared with other FERA employees. One drawing captures four of the artist's coworkers seated at their desks, three typing and one writing, lamps hanging low overhead. In fact, Hollingsworth had at least one sketchbook made from bound "Emergency Relief Administration for Mississippi" letterhead.[19] In a more formal piece entitled *Elevator, Tower Building*, the artist's affinity for illustration is married with his growing proficiency as a fine artist. The oil painting depicts the hustle and bustle of a winter morning (see p. 63).

Jackson native and Pulitzer Prize winning author Eudora Welty (1909–2001) was employed by the Works Progress Administration, which was also located in the Tower Building. At the time, she worked as a junior publicity agent and was simultaneously pursuing photography and writing.[20] Though she and Hollingsworth were never close friends, there was a mutual respect between the two and their paths often crossed. Hollingsworth's watercolors were featured in a

July 1934 exhibition, probably his first after returning to Jackson, at the Municipal Art Gallery alongside photographs by Welty and Hubert Creekmore.

The Municipal Art Gallery, located at 839 North State Street, was the center of Jackson's art world from the 1920s until the late 1970s. During that time period, it functioned as a club house for several organizations, with the Mississippi Art Association as its primary occupant.[21] Having just returned to the comparatively small town of Jackson from Chicago, Hollingsworth naturally gravitated toward the gallery and the other artists who frequently showed their work there. His local contemporaries, in addition to Welty, included artists Caroline Compton (1907–1987), Marie Hull (1890–1980), Mary Katherine Knoblock McCravey (1910–2009), Gray Layton (dates unknown), Bessie Cary Lemly (1871–1947), Helen Jay Lotterhos (1905–1981), Mildred Nungester Wolfe (1912–2009), and Karl Wolfe (1904–1984), who became Hollingsworth's closest friend.

Hollingsworth continued to build his reputation as a fine artist during his tenure with the FERA. Soon after his return to the state in 1934, Helen Jay Lotterhos wrote about her anticipation to see what the artist would produce in the future. "This is a very credible showing of work," she said about an exhibition of Hollingsworth's watercolors at the Municipal Gallery, "and makes one eager to the development in style…of the work of this artist. It will be interesting also to note what the next few years of work outside school, based on the knowledge and talent evinced here, will indubitably bring forth."[22] Indeed, Hollingsworth continued garnering acclaim in the local media for artwork shown at the Municipal Gallery. He received awards for both a portrait and a landscape at the 1934 state fair, a silver ribbon in the gallery's twenty-third annual exhibition in 1934, and a gold medal for the painting *Tired, Oh, Lord, Tired* in the twenty-fourth annual exhibition the following year. An attendee to that exhibition shared in the local paper, "Mr. Hollingsworth's painting 'Tired, Oh, Lord, Tired,' which shows unemployed men stretching in exhaustion on a park bench, a crumpled newspaper on the ground. This, the visitor will decide is immediately evocative, touching our real feelings, commenting on conditions that really exist in a living world; this, at least, is a purpose of art."[23]

Sketch for **Tired, Oh, Lord, Tired**
1935
graphite on paper
7.25 x 8.5 in.
Collection of Hunter M. Cole

Black and White
1935
oil on fabric
20 x 24 in.
Gift of Mrs. William Hollingsworth
1944.001

While achieving great success locally, Hollingsworth was simultaneously pursuing artistic opportunities elsewhere. His first significant achievement as a professional artist outside his home state was the inclusion of his painting *Black and White* in the annual exhibition at the Cincinnati Museum of Art in June 1935. The same painting was shown in October 1935 in the *All-American Show* at the Art Institute of Chicago. *Black and White*, one of the earliest examples of his artwork featuring African Americans, displays the artist's mastery of light and color. The figures in the painting foreshadow the coming series of artwork portraying the black community, particularly those depicting the thriving Farish Street district. Hollingsworth uses the interior of "Pete's Place" to illuminate the colorful clothing and social interactions happening outside the diner, in which the viewer plays an active role. Hollingsworth's friend Karl Wolfe spoke of his appreciation for the work in a 1939 newspaper article, "I happened to be in Chicago several years ago and dropped in to see what was probably the most famous show the Chicago Art Institute ever had. Anyone who goes to exhibitions often enters a room, casts a glance around, and is immediately drawn to some particular picture in the room. I had that experience and was drawn to 'Black and White.' Walking across the room, I picked it up and there was Hollie's signature."[24] From there, the painting went on to the *Second Annual Exhibition of American Art* in New York City in July 1937, ultimately becoming a part of the Art Association's (Mississippi Museum of Art) permanent collection in 1944.

William Hollingsworth's depictions of African Americans loosely fall into two categories: genre scenes and works that catered to the early twentieth century stereotype of the carefree "negro," both of which the artist painted from the mid-1930s until the end of his life. The artist enjoyed painting black figures in

genre scenes, and these works included urban settings from Farish Street, residential neighborhoods with dirt roads, people working in the fields outside of town, and an occasional formal portrait. The artwork that falls into this category reflects what can be interpreted as a relatively accurate depiction of life in the black neighborhoods of Jackson. There is little stylization or commentary contained in the compositions.

The other group of work portrayed those in the black community as happy-go-lucky, most with exaggerated features, functioning as characters acting out a narrative. By far the most repeated composition in this category involves three or four black figures running along a street in the rain (see p. 69). The idea for this compositional arrangement came to the artist one summer about 1936, while he, Jane, and son Billy were living at 763 Madison Street in Jackson—their home since 1935. He looked out the window and saw "four little negroes, dressed finely, parading to church," according to a newspaper reporter several years later. The artist was taken with the scene, sketched it, and did not think of it again until he installed

Cross Road
no date
oil on canvas
20 x 24 in.
1987.064

Dark Romance
1939
watercolor on paper
10.75 x 8.75 in. (sight)
Gift of the artist
1939.001

Thanksgiving Day
November 27, 1941
watercolor on paper
16.5 x 21.5 in. (sight)
1987.017

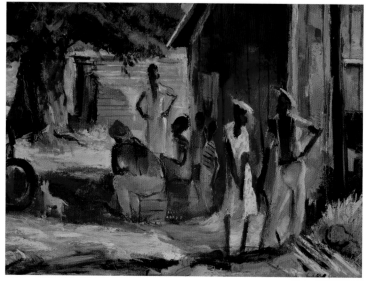

Sundown Chatter
1940
oil on canvas
18 x 24 in.
Gift of Mrs. Stuart Irby and Mrs. Lloyd Milam
1981.012

the inexpensive watercolor in the art gallery's Christmas sale, and it sold immediately. When gallery hostess Mrs. Ruth Roudebush White asked for more of the same, the artist delivered, and those sold quickly too.[25]

Hollingsworth began to refer to these popular pieces as "pot-boilers,"[26] because of the almost guaranteed sale that contributed to the artist's income. While sketching and painting these pieces for entertainment value, the artist likely had no idea that they were insensitive or that they would appear racist in the coming decades. In the post-slavery, pre-Civil Rights Movement era of the 1930s and 1940s, many whites—even those inclined to sympathize with poor conditions and mistreatment of the black community—had grown accustomed to segregation and were disinclined to upset the status quo. In general, white society looked down upon blacks, taking the paternalistic viewpoint that African Americans were simpleminded and carefree. Artists (including fine artists, illustrators, filmmakers, and more) exploited this widespread stereotype for the entertainment of the white population who consumed their creative products. Hollingsworth, in his own words, reflects this reality when speaking about his depictions of the black community, "Negroes are more unaffected in their affectedness than white people. They strike attitudes, but they do it deliberately, loud socks, a jaunty pull to the hat, a bold walk, an extravagant gesture."[27] Later in 1938, he elaborated on the subject, "I have on innumerable occasions visited Farish, Mill, and those other streets in Jackson peopled in the main by the colored man and his girl. ... I like to paint the Negro. I like his humbleness, his affectations [sic] nature, his irresponsible grandeur. But I am not primarily interested in any race. People—the human figure—interest me."[28] Though Hollingsworth reiterates black stereotypes, he also shows openness to people of other races, both by mentioning his visits to black neighborhoods (where most whites of the time would not dare venture) and by underscoring his desire to paint the human figure, black or white.

Hollingsworth's drawings, paintings, and prints of the African American community in Jackson were not only popular among local art collectors; they were well-received across the country, like the success of his painting *Black and White* in 1935 and 1936. The year

1937 brought another milestone for the up-and-coming artist, when his watercolor *Siesta* (see p. 65) was included in the Art Institute of Chicago's annual watercolor exhibition, winning a major award. Hollingsworth received a letter from Art Institute director Robert D. Harshe informing him that he had won the William H. Tuthill Prize of $100.[29] Local papers reported that the same picture had hung for weeks at the Municipal Art Gallery with a price tag of $7.50 before earning its creator the substantial award. The award was also touted in the *Chicago Tribune*, which published the names of the esteemed jury as Rainey Bennett (1907–1998), Charles Burchfield (1893–1967), and George Grosz (1893–1959).[30] *Siesta* sold to Mr. E. L. Hodson of Chicago, who recommended the artist for inclusion in the Chicago Galleries Association.[31]

In October 1938, Hollingsworth's watercolors were included in a three-person show alongside Arnold E. Turtle and Rose K. Boettcher, and his work—again, the paintings of African Americans—received attention in the media. C. J. Bulliet noted in the *Chicago Daily News* that "William R. Hollingsworth, Jr. of Jackson, Miss. is one painter who doesn't insist on the proverbial laziness of the Southern Negro. His black men "rest," oftentimes, at the filling stations, in cafes, and on the front porch, but though their bones may be weary, their conversation is animated. His dark girls glide instead of shuffle along. Hollingsworth, in other words, is using his faculties of observation instead of himself falling into the lazy habits of 'true-to-type' artists."[32]

In January 1938, still working for the FERA, Holllingsworth received a letter from Juliana Force, director of the Whitney Museum of American Art, in which she invited the artist to show one watercolor in the 1938 *Annual Exhibition of Contemporary American Sculpture, Watercolors, Drawings and Prints*. In response, the artist shipped a painting of Farish Street for inclusion in the show. The local newspaper reported on William Hollingsworth's achievements, "Virtually unknown three years ago, Mr. Hollingsworth has now taken his place with leading, significant Southern artists. His water colors on negro subjects are marked by rare humor. He has also made distinct strides in the use of oils, and in the portrait field."[33]

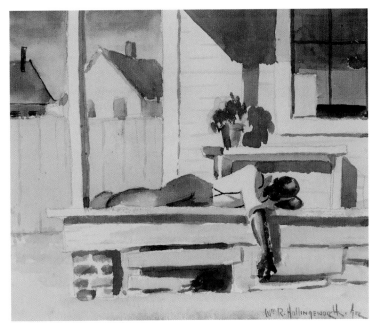

no title
no date
watercolor on paper
5 x 6 in. (sight)
Collection of Mr. and Mrs. William Harold Cox, Jr., Jackson, Mississippi

Hollingsworth family at home on Madison Street, Jackson, February 1935.

Melon Carriers
1941
watercolor on paper
16 x 20 in.
Collection of Stacy and Jay Underwood, Jackson, Mississippi

Life as a Professional Artist

In 1939, Hollingsworth's government work was concluding and his art was becoming a commercial success, so he decided to leave work in the Tower Building and pursue his art career full time.[34] By the end of 1936, Hollingsworth had moved his family into his childhood home on President Street, where his father still lived. There, he was able to focus on his passion for art while surrounded by those he cared about most, and who were often the subjects of his work. He set up a studio in a small room beside the screened porch in the rear of the house, that received light from the north and the east through its two windows. During the day, Hollingworth sketched, painted, worked at the Municipal Art Gallery, and taught college and younger students. In the evenings he spent time with family and friends, listened to the radio, read, and recorded his thoughts in journals. It is unclear whether Hollingsworth kept a diary prior to 1940, but in 1981 Jane Hollingsworth published numerous journal entries he made between November 15, 1940, and June 28, 1944, in *Hollingsworth: The Man, the Artist, and His Work* (University Press of Mississippi). Though edited, the diaries offer an intimate look at the artist's daily life, including career successes and struggles.

Success on a National Scale

Soon after beginning his life as a professional artist, William Hollingsworth attained several significant achievements. In early March 1940 he received a letter stating that his painting *Drear* had been accepted into IBM's Gallery of Science and Art at the New York World's Fair. It went on to win seventh prize ($100) there, selected by a jury including professionals from the Metropolitan Museum of Art, the National Gallery of Art, and the Art Institute of Chicago. In April 1940, his oil *Black and White* was included in a large exhibition entitled *First Exhibition of Arts and Artists Along the Mississippi* at the Davenport Municipal Gallery in Iowa. It hung alongside ninety-three other works from artists like Thomas Hart Benton (1889–1975), Caroline Compton, John Steuart Curry (1897–1946), Adolf Dehn (1895–1968), Marie Hull, Doris Lee (1905–1983),

John McCrady (1911–1968), Dale Nichols (1904–1995), Karl Wolfe, Grant Wood (1891–1942), and Ellsworth Woodward (1861–1939). In September 1940 twenty-three of his watercolors received high praise during their inclusion in the sixteenth exhibition at the Delgado Museum of Art in New Orleans. Frances Bryson of the New Orleans *Sunday Times-Tribune* stated, "They are superb, and if that sounds gushing, we mean just that."[35]

Though Hollingsworth appeared to be making strides as a professional artist, his accomplishments were not enough to satisfy his lofty goal of having a one-man exhibition in New York.

On December 21, 1940, he wrote, "I *must* get to the top—and feel that I am starting that long, long road at last. Confidence in self is better—eye surer—hand more facile—knowledge more thorough, and I hope and pray darkness will not fall until these seeds bring harvest." And the following day, "Got to thinking about 'One-Man' shows in New York. I cannot help but feel that ere long I will be ready…though I am thinking less and less of critics as time passes—particularly N. Y. critics. They see so damned much that their stomachs are bound to be haywire. Many times I suspect they glim over something good (and by someone new) because of this very saturation of all that is good and bad that passes their review…I feel also that I am doing better things than so much of that that is in NY Galleries on and on and on!!"[36]

He continued pursuing opportunities around the country in the early 1940s, experiencing certain successes but also major disappointments. In 1941, Hollingsworth's artwork was shown in a one-man exhibition at Illinois Wesleyan University, included again in the *Second Exhibition of Arts and Artists Along the Mississippi* in Davenport, in a two-person show at Athens, Georgia, in the *National Water Color Exhibition* at the Oakland Museum, California, and in the *Southern States Art League 19th Circuit Exhibition*. A watercolor of a barbershop was chosen by the Federal Works Agency Public Building Administration for "the decoration" of a marine hospital in Lexington, Kentucky.[37] The artist received an honorable mention prize at a national watercolor exhibition at the San Diego Fine Arts Gallery in California, and he sold the watercolor *Melon Carriers* to IBM from the national art week show in the same year.

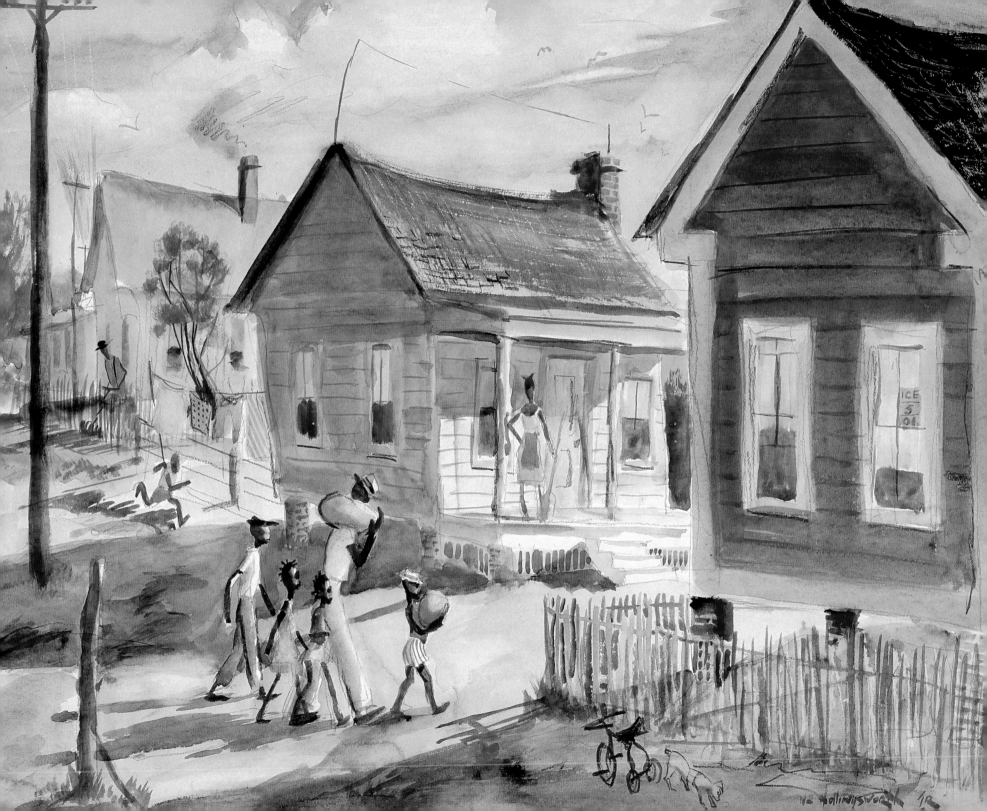

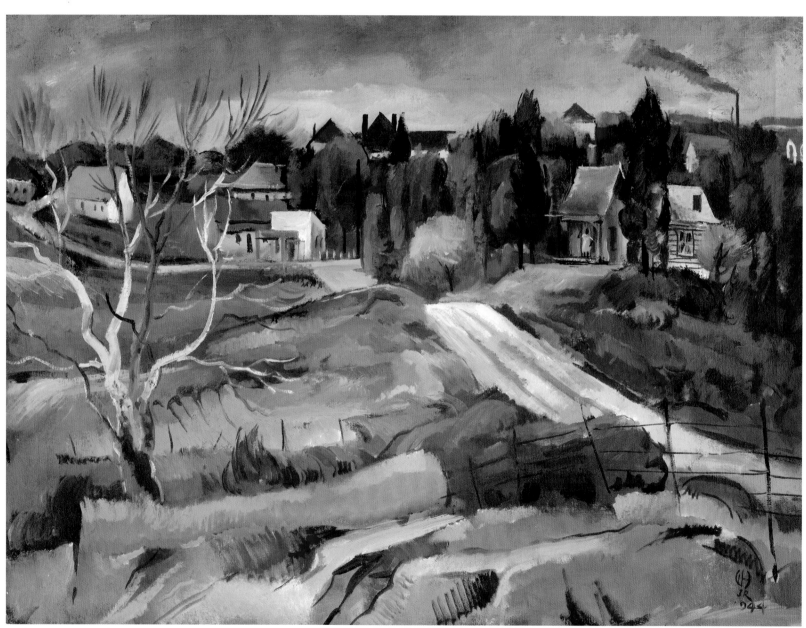

Landscape #35
March 1944
oil on canvas
24 x 32 in.
1987.057

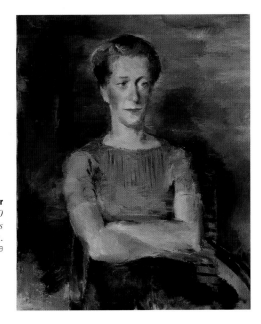

Frances' Green Sweater
December 1940
oil on canvas
32 x 26 in.
1987.169

On December 30, 1940, Hollingsworth shipped two paintings for jury at the Pennsylvania Academy of Fine Arts, and he was filled with much anticipation about the outcome. He wrote, "...crated and shipped 'Green Sweater' and 'Hitchhikers' to the Penn. Academy. Godspeed! O how I *do* hope *one* of them gets accepted. But not to expect—can only hope. Well—*HOPE*!" By January 2, "...hopes are winging to Philadelphia with my two pictures—if—IF—one of them will or would or may or might be accepted...A little perfunctory tonight, I fear. Sometimes we just feel that way. Well—to hope and hope and hope and pray and paint and paint and paint and paint and pray." Ultimately neither painting was included in the exhibition. In January 1942 he shipped the oils *Conversation* and *Black Sunday* to the *Virginia Biennial*, wishing them "Godspeed!" as he did with all his paintings that traveled. On February 23, he received word that both of those paintings were rejected. His reaction was grim, "...the day was dark, rainy, dejectionable." More disappointment came when he learned he did not receive a fellowship from the Guggenheim Foundation for which he applied in February 1942. [38]

On April 9, 1942, Hollingsworth learned of his award for an oil painting called *Brown and Wet* (see p. 77) at the *Southern States Art League*

exhibition in Athens, Georgia, via telegram at 11:48 a.m., "YOU RECEIVED THE BENJAMIN PRIZE WE ARE THRILLED=MRS W Q SHARP."[39] His journal entry for the day, "Happy days!!"[40] The usual cash award was given in war savings bonds that year.[41] He also received special mention in the *American Prize Winners Show* at the Chicago Arts Club, and was featured, along with Karl Wolfe, in an exhibition at the Brooks Memorial Art Gallery in Memphis.

One 1942 sale to a private collector stood out among the others. Acclaimed actress Maureen O'Hara, whose husband Will Price was from McComb, purchased an oil called *The Rains*. The artist received a letter on 20th Century Fox letterhead dated November 25, 1942. Price stated, "We are both crazy about the picture and it is hanging in the most prominent spot in our living room. Maureen is giving it to me as a present and she sent you a check in yesterday's mail."[42] Local papers picked up the news of the sale, reporting on January 17, 1943, in "Another Hollingsworth Goes To Hollywood."[43]

Hollingsworth paintings were included in several exhibitions in 1943, including *American Prize Winners* at the Arts Club of Chicago, a *Combined Exhibition* of the New York Water Color Club and the American Watercolor Society at the Fine Arts Building in New York, followed by the *76th Annual Exhibition of the American Watercolor Society* at the National Academy Galleries in New York, and an exhibition of fifteen watercolors at Findlay Galleries in Chicago, for which he received much praise. On April 11, 1943, Hollingsworth noted in his journal that he, "Secured a Sunday Chicago Tribune, and discovered to my pleasure a flattering mention of my Findlay show in E. Jewett's column."[44] Eleanor Jewett's was indeed a glowing review, in which she stated, "The water colors...are outstanding. Hollingsworth has a delicious sense of humor and a marvelous feeling for color. His work is alive, sensitive and in picture after picture offers details such value, such beauty, that they are impossible to forget. He is one of our most gifted younger American painters. His show is another 'must.'"[45] On April 25, the *Jackson Daily News* reported a Chicago artist as saying that Hollingsworth's paintings were exhibited at Findlay Galleries, "in a very ritzy, top-notch fashion." The reporter went on to say, "Hollie has done some hard work in the last year

Another Hollingsworth Goes To Hollywood

Another Hollingsworth went to Hollywood as Maureen O'Hara, beauteous film star, purchased another of William Hollingsworth works to add to the collectin started several years ago by her husband, Will Price, formerly of McComb.

The large oil entitled "The Rains" which depited a typical Hollings-

William Hollin a number, som and some he Miss O'Hara. added steadily by this popular Another fo who makes him les, Charles Cr of Holly's work

"Another Hollingsworth Goes To Hollywood," Jackson Daily News, *January 17, 1943.*

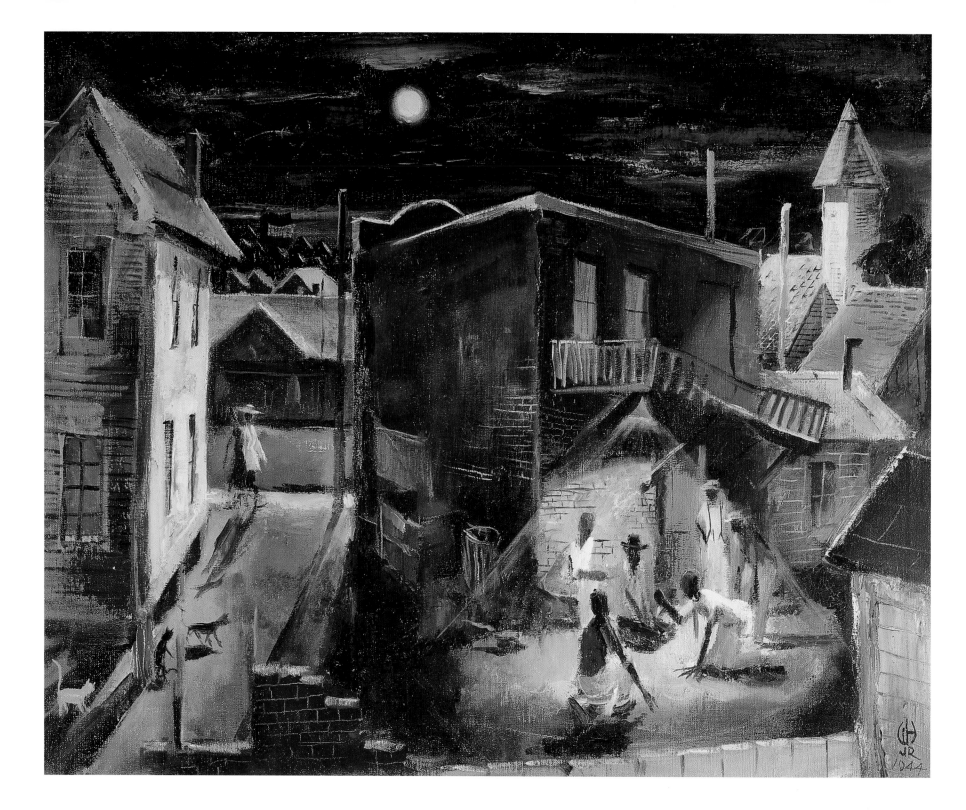

Ah, the Mystery of a Southern Night
1944
oil on canvas
24 x 30 in.
Private Collection, Princeton, New Jersey

and it's good to see his work collect the recognition it deserves."[46] Ironically, Hollingsworth received word on April 22 that he was not admitted to the exhibition at the Art Institute, the same exhibition that won him the prestigious Tuthill prize six years earlier. On April 23 he stated, "The Chicago Disappointment set more heavily than I care to admit...Cannot understand why I "make" all wc shows in the country and yet can't get accepted at Chicago."[47] In the fall of 1943, Hollingsworth did have another exhibition in Chicago, this time at the Chicago Galleries Association. Jewett remained an admirer of his work, and she wrote in the *Chicago Sunday Tribune* on October 10, "Mr. Hollingsworth is one of the cleverest and ablest painters working today. His approach is fresh and his craftsmanship is enviable."[48]

In the fall of 1943, Hollingsworth worked to achieve a mutually-beneficial relationship with Ferargil Galleries in New York, which also represented Arthur B. Davies (1863–1928) and Lamar Dodd (1909–1996). Correspondence and paintings were exchanged between the artist and Mr. Price, his contact at the gallery, with the goal of finding suitable subjects for an exhibition in the spring of 1944. On November 22, Hollingsworth was excited about the potential, "Maybe I'm to, at long last, have a N.Y. dealer. Maybe. Would seem that way. O boy." But by December 10, "Disappointment. Came from Price a letter—likes a few of what I sent but thinks will send most back...Am writing him that I *won't* paint calendar art, if it takes that. Disappointed in him—his 'choices' are the really not-so-good ones—the *real* stuff he seems to overlook. Well, maybe I picked the wrong dealer. We'll see." Mr. Price went on to include five watercolors by Hollingsworth in a group show at Ferargil Galleries in March 1944.[49]

On February 24, 1944, Hollingsworth began work on a watercolor with a "'cute' theme: 'Mystery of Southern Night': moon, clouds, shacks, behind which, in foreground some Negroes play dice." Unhappy with the results, he began the theme again, "rearranging, unifying color, changing perspectives, etc. ..." The next evening he writes, "Think it one of my best, sincerest water colors." Still considering the theme in March, on the first of the month he, "Began with pretty good start, the oil, 'M. of S. N.' Fun doing it, and the night light is a good problem. The biggest job though is the design and

keeping the color from becoming *blah*!" His work on the painting paid off when the oil *Ah, the Mystery of a Southern Night* received the Rhodes S. Baker Memorial Prize for the best work in any medium at the twenty-fourth annual exhibition of the Southern States Art League.[50]

Promoting Fine Art in the Community

Hollingsworth's career operated on two different planes: his relevance on a national scale coupled with his work in central Mississippi, where he was much appreciated and played an important role in promoting quality artwork to Southern audiences. He had experienced world-class art during his time at the Art Institute, and he worked to present high-caliber art in Jackson, as well as to educate the public on fine art and artists through speaking engagements and newspaper articles. One particular article included his commentary on the local reaction to modern art, "One hears just a little too much of the jeering and scoffing which modern, top-ranking American art is greeted with when exhibited in the south, and if the progressive, purely-aggressive type of art is actually being encouraged and promoted in a southern locality, then it speaks well for the advancement and awakening of the southerner to appreciation of sincere and honest art."[51]

From the time he returned from Chicago, William Hollingsworth was an important part of the Mississippi Art Association as a participating artist. When he left his job at the FERA, however, he became more active in the Association, developing the exhibition schedule, handling the incoming and outgoing artwork, and even assisting in raising money for the organization. Artist Karl Wolfe was equally as involved before he left for the war, and other artists and board members assisted in certain duties. A "hostess" tended to visitors, sold artwork, and answered phone calls. Hollingsworth spent many days at the Municipal Art Gallery dealing with the logistics of installing or shipping artwork. On January 26, 1942, after working on the annual exhibition there, he says, "Devoting a day to it, with nothing else to do I enjoy it—it means handling pictures."[52] He also facilitated juried awards and exhibitions, and he met with art dealers interested in selling to the Association's collection.

First of December
December 1, 1943
watercolor on paper
21.5 x 29.5 in. (sight)
1987.046

On March 30, 1943, he summarized his work for the day, "Busy as hell. Contracted for catalogues for the show—hung the entire show; 75 paintings. And late tonight wrote press releases. One-man art association! Also got check from treasurer to buy the $50 Bond—the prize. And also received check to buy painting—so the Fredenthal is *OURS*!!"[53] The next day, "Another helluva busy one—all for the gallery. Numbering the paintings, making some notes for gallery talk, picking up catalogs, sealing, addressing, stamping some for mailing to artists, writing publicity for art magazines as well as letter to the editors, buying the Bond of prize and on and on and on."[54] On September 23, 1943, Hollingsworth was heavily involved in an auction of paintings at the Art Gallery for the war bond drive. The event raised an impressive $18,000. Hollingsworth even took time to teach landscape painting to high school students at the Municipal Art Gallery.

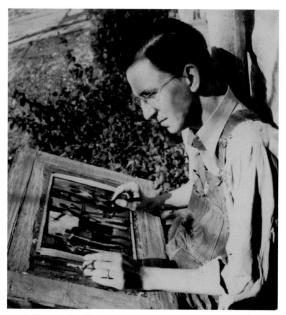

Hollingsworth painting at home, late 1930s.

The Art Association was important to William Hollingsworth as an educational, fine arts institution, and also for its involvement in advancing his career. He won his first prize in the amateur exhibition there in 1933 and his work continued to be shown there throughout his life. Five works were featured in the *National Art Week Exhibit* in November 1940. He received the gold ribbon in the annual exhibition of 1941. *Melon Carriers* (see p. 21), which sold to IBM, was included in the *National Art Week Exhibit* of 1942. His painting *The Coal Hunter* (see p. 80) was awarded honorable mention in the first annual *National Watercolor Exhibition* at the Association. He received a solo exhibition there in October 1942, and his work was included in several other group shows throughout the years.

One of Hollingsworth's most significant contributions to arts education came in September 1941 when he was tasked with initiating a department of art at Millsaps College in Jackson. He was encouraged by Dean W. E. Riecken and appointed by President Marion L. Smith to head the department.[55] The *Jackson Daily News* reported that Hollingsworth would, "endeavor to acquaint the student with the elements of good pictorial and applied design, and to outline the working theory of color in painting and in relation to the home and everyday life of the individual. The fundamentals of perspective drawing, together with free hand sketching, will be correlated to the course."[56] It is clear that the new professor relied heavily on his classical training at the Art Institute for the courses he taught at Millsaps three days a week. As there was no degree offered in fine art, it was often difficult to attract students to the class, and even keep the number of students at an acceptable level. However, Hollingsworth had the support of the administration, with the president himself assuring the artist that they were "going to make the Art Department click!!"[57]

Making Art

As much time as Hollingsworth invested in promoting the local art scene, his obsession remained making art. Throughout his diaries there are references to his study of other artists' work, ideas for various series of his own work, notes about outings to sketch and paint in the field, observations on color, and general thoughts on creating art.

Hollingsworth found inspiration through various avenues, including prints and books. He ordered reproductions of work by great artists like Adolf Dehn, Charles Burchfield, John Whorf (1903–1959), Yasuo Kuniyoshi (1893–1953), and more. He also had a collection of books on artists that included Paul Cézanne (1839–1906), Pablo Picasso (1881–1973), and Henri Matisse (1869–1954). When possible, he traveled to such museums as the Brooks Memorial Gallery in Memphis or the Delgado Museum of Art in New Orleans to see exhibitions, such as the Delgado's exhibition on Picasso in January 1941.

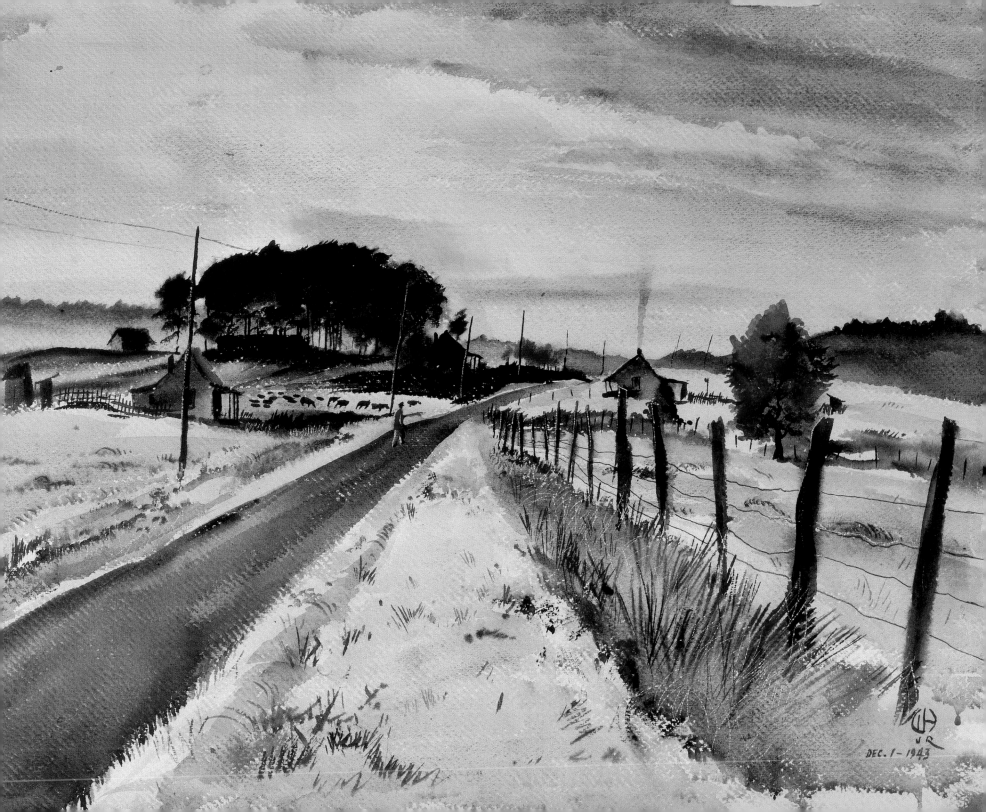

DEC. 1- 1943

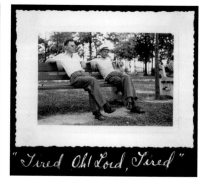

Two Old Boys
(Old Canton Road, Jackson, Miss.)
October 5, 1943
watercolor on board
15 x 20 in.
1987.087

Lee Downing
1944
graphite on paper
8.75 x 6 in.
1987.196

Hollingsworth with friend Lee Downing, 1943.

When schedule and weather allowed, the artist left his home to paint en plein air. Locations encompassed downtown and west Jackson, Old Canton Road northeast of the city, the Natchez Trace Parkway, Edwards, Flora, and areas just south of Jackson, among others. Hollingsworth expressed interest in visiting and painting the gulf coast, but there is no evidence that he did so. In 1941 and 1942, Hollingsworth went on a number of these sketching trips, often with his good friend Karl Wolfe, whom he called "Jack." They traveled in Mr. H.'s 1941 maroon Dodge. He relished these quick trips around central Mississippi. On January 6, 1942, a day he went out alone, he said, "Cold. And painting out in it—boots, overcoat, muffler, head wrapped and gloves. With a thermos of coffee. Real damned fun. … And it is so fine to get away from town and people and noise and war talk and war news and alone and singly watch and listen to nature. Grass and weed and brush and bare arms of trees and waving fields and leaden skies and lonely cold winds."[58]

On Saturday, January 10, Wolfe stayed late at Hollie's home discussing art and looking at pictures. The following Thursday, January 15, "Jack and I took off on a sketching trip to Brandon and vicinity today—gone till sundown each of us doing four sketches… and all fair, mostly good. Had a swell day—We painted, talked, smoked, laughed, ate eggs and bacon and coffee, drank a Coca Cola, lolled in the sun on someone's loading platform and had a bang up swell day."[59] By September of the same year, Wolfe had been drafted, and their extended time together ended, though they remained close friends. Another friend, Lee Downing also accompanied Hollie to sketch, and he and Leon Burton often discussed art with Hollingsworth or helped him with duties at the art gallery.

William Hollingsworth was sensitive to light, color, and weather, and these elements were poetically noted in his journals and often emerge in his artwork. On December 3, 1940, he described a typical city scene, "Yesterday at dusk was breathtaking. Riding along the r.r. tracks on the west side, hill and houses silhouetted, lights shining brightly, clouds dark and featherly as smoke, and a very faint tinge of pink in the bottom of the sky. Absolutely wonderful." December 14, 1940, was declared a, "Swell day. Chilly wintery cloudy misty murky day." The following day, "…long, rainy, enjoyable." It seemed that the typical warm, sunny, Mississippi day was not desirable, and he longed for the snow he had experienced in Chicago, which he confirmed in his December 7, 1940, note about listening to a Chicago radio station, "…their repeated talk of snow and cold makes me homesick for Chicago with wind and snow and briskness and pep and good stuff…" On January 26, 1943, "with trees and fields covered with ice, I took out to paint: did one wc which turned to ice as I painted, and it is plenty good." The surviving watercolor is called *The Ice-covered Tree*, and it betrays the frigid temperatures in the pattern created by the settling of pigment as the ice crystals thawed.[60]

On April 6, 1943, the artist traveled to Flora. He was, "Trying landscape sun-diffused, color weakened, light-flooded. Do better, much better, when clouds are low and heavy. Color then is rich, values deep and in lower harmony." Hollingsworth was not keen on the color green, which abounds in the lush Mississippi springs and summers. On May 27, 1943, he said about his watercolor of the day, "Though it has ga-reen all over it has many good passages, and am very pleased." In one on-site sketch, he notes that one tone should be "garish green." His artwork often depicted inclement weather, and he was able to record a rainy day masterfully. He was particularly fond of a work he completed on February 17, 1944. He explained in his journal, "Today, being a sloppy, rain-soaked day

of wetness, I betook to a down-the-street spot (in the car) and did a large wc of the place…it owes [Charles] Burchfield a little…with atmosphere glistening with wet asphalt and pavement. In other words—success—a show number."[61]

On days he stayed in his studio, Hollingsworth focused on works such as still lifes, portraits, and completing sketches and loose paintings made elsewhere. Still life paintings included pitchers, bottles, and decorative items like floral arrangements. In fact, gallery hostess Ruth Roudebush White kept Hollie informed about the best blooms. On February 9, 1944, she advised him that the jonquils would be ready the very next day. On February 10, he wrote, "Painted the flowers Mrs. White procured, all a.m., and the latter part of p.m."[62]

At the end of 1940 Hollingsworth was quite focused on portraiture, even working in Karl Wolfe's studio in the afternoon because it had better light at that time of day. He was pleased with his work, while recognizing the need for improvement. On December 11, "'Tis in a way the most controlled figure I have done—no giving way to superficialities—no flattery—no pretty paint…but it shows I need to do a lot of figure work in this vein to produce something of real weight." Still thinking and writing of the painting on the thirteenth, he says, "Now, after two days of not seeing it, I find the portrait very likeable—more so than before…I am right proud of it…and I want to do some more right away." He continued taking portrait commissions throughout his life. In April 1944, he was smitten with his two-year-old subject Ward Whittington (now Sumner). "[She] completely won my heart," he said, "the sweetest child I've seen, and so inspired that I believe the portrait is going to be a pip."[63]

Many of his portraits focused on his immediate family, including himself. Several self-portraits of the artist survive,

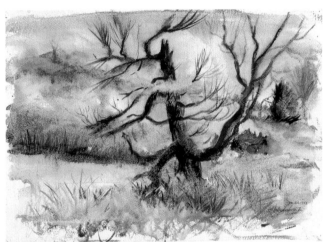

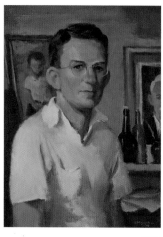
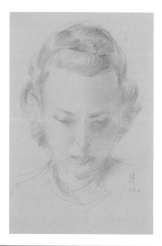

Self-Portrait
April 1943
oil on canvas
24 x 18 in.
1987.040

Jane
1944
graphite on paper
5 x 3.5 in. (sight)
1987.059

Dad
August 1939
oil on canvas
24 x 20 in.
1987.011

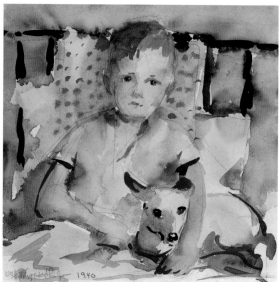

Wm. Robt. III, 1 Mo. Old
August 1933
ink and graphite on paper
8.25 x 10.75 in.
1987.277

no title
1939
Conté crayon on paper
6.75 x 4.75 in.
1987.236

Billy poses with his doll, 1938.

Tonsils Gone
1940
watercolor and graphite on paper
10 x 10 in. (sight)
1987.093

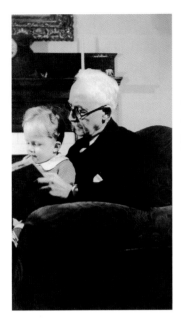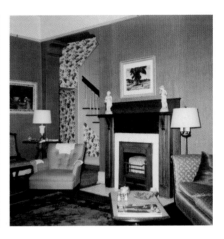

including graphite sketches (see p. 80) and large and small oils. One meaningful self-portrait includes depictions of two framed portraits in the background—of the artist's father and son—over each of his shoulders. His wife Jane appears in a few sketches and paintings, and near the end of his father's life and even after, Hollingsworth lovingly captured Mr. H.'s likeness. The most numerous by far, however, are the sketches and finished pieces that depict the artist's only son, William Robert Hollingsworth III, known as Billy during his early childhood. The first eleven years of the child's life are chronicled, from the one-month old in a blanket to the boy holding a Charlie McCarthy doll, playing the organ, reading, and in formal portraits at nearly every stage of his life.

Life with the Family

In the early 1940s, William, Jane, Billy, and Mr. H. all lived together at 754 North President Street. Hollingsworth adored his father, as indicated by his journals, artwork, and people who knew the family. His sole parent growing up, Mr. H.'s role in Hollie's life was immense. He provided his son the funds to study art and was supportive of his artistic career. Hollingsworth's emotional reliance upon his father was recorded in the artist's words on November 21,

1940, Thanksgiving, "Mr. H. is 'The Rock' now…with him to cling to and to back me up, I can go on, but when his aid is taken away, I cannot see what there will be to do."[64] William Robert Hollingsworth III recalled with fondness sitting on "Granddaddy's" lap while he smoked Sir Walter Raleigh tobacco in his pipe. Several family photographs show the two together, enjoying a book. Careful photography and angles in painted portraits hide the fact that Mr. H. was missing his right hand, having lost it saving a child from a firecracker.[65] Mr. H. lived to be seventy-seven years old.

Jane, too, was supportive of Hollie's career, playing hostess at numerous Art Gallery events and helping her husband install student art at Millsaps on occasion. She herself designed and made sophisticated attire and costumes for the public, which helped to support the family financially. She had a studio inside the home on President Street where she fashioned garments for the public that included wedding trousseaux, costumes for the symphony, and even a dress for the Maid of Cotton, who was crowned in Memphis at the Cotton Council of America meeting. Likewise, she excelled in interior design. The home on President Street was essentially a bachelor's home when the younger Hollingsworths moved in, but Jane spruced it up with gunmetal gray paint, white trim, and fashionable window dressings.[66]

Billy reads with his grandfather, 1936.

Jane (third from left) at Mississippi Art Association Open House, January 1941.

Living room in Hollingsworth home, 1950s.

Living room in Hollingsworth home, 1950s.

Sketch of Billy
August 21, 1938
graphite on paper
8.5 x 5.63 in.
1987.165

The family enjoyed entertainment like radio programs, records, and playing musical instruments. Hollingsworth recorded in his diaries the music he listened to as he painted: Beethoven's *First Symphony in C Major* and *Seventh Symphony*, Cesar Franck's *Symphonic Variations*, and opera on occasion. The youngest Hollingsworth recalls a harmonium (pump organ) once owned by his grandmother that his father found in the attic, "Daddy used cypress wood to make the Black Keys for the harmonium and obviously repaired the billows which were needed…Daddy got a book at a music store that taught himself how to enjoy playing the keyboard. I recall him playing LARGO many times…I ended up using that harmonium when I started taking piano lessons. That was in mid [to] early '40s. We had no piano until Dear Aunt Nellie (Nellie Oakley DeSaulniers, a great aunt) in Moline, Illinois sent us her piano…Mother used to play ragtime on the piano…Ironically, when I arrived at the Abbey to begin my monastic life there, the Brother Instruction took me to the Chapel and pointed out the Harmonium there and said, 'I suppose you don't know how to play a Harmonium?' I smiled and said I have played one for a couple of years! Hence my organ playing began."[67]

Hollie wrote of his thirty-third birthday, "Have 4 lovely new colorful handkerchiefs, a bottle of shaving lotion, a pocket-checkerboard and, mostest, an album recording of Rimsky-Korsakov's Coq D'Or Suite—from Jane. We had cocoa (crowned with marshmallow) and angel food cake, and all was swell. Felt like a boy again."[68] On February 20, 1943, he had, "ordered from Wurlitzer, Chicago, a new harmonica—the cost of $12.00!! But they are so scarce, the best being German made, that I am taking it to be worth it."[69] Hollie's son says his father played, "a cool harmonica."[70]

"Boy," the family terrier, was also an important part of the family, and he made it into numerous family photographs, sketches, and paintings. He is even mentioned in the published diaries several times, including a trip to the veterinarian for vaccinations, and a humorous note on November 27, 1943, about returning from playing chess to, "bathe the dog, who got mixed up in my oil paints today and was one *blue* dog." One snowy morning the family enjoyed playing outside together, "The snow was light, barely covering the

ground and by noon was gone but not before we all had tingling fun ('Boy,' too!) with snowballs, etc."[71]

With the Century, Majestic, and State theaters on nearby Capitol Street, movies were also a source of entertainment. Hollingsworth enjoyed W. C. Fields, calling him an "ace at comedy." He called Alfred Hitchcock's *Suspicion* "a really marvelous show," and particularly liked the actress Hedy Lamarr, describing her succinctly with "Manoman!"[72] After taking Billy to see "one clever movie," *The Major and the Minor*, Hollingsworth returned home to read Hemingway short stories which he had purchased that day, at the same time he purchased Eudora Welty's new book, *The Robber Bridegroom*.[73] Hollingsworth read in the evenings, particularly enjoying "detec-a-tive" novels, as his son recalls. He also remembers his father's humor and that he "had fun with the English language."[74] Hollie wrote, too. This is evidenced by the volume of his diaries published in 1981 by Jane, as well as the newspaper articles he wrote for the Municipal Art Gallery. In an unpublished journal entry from February 10, 1943, however, he mentions more, "Finished a short, short story I started several days ago, and mailed same to the *Atlantic Monthly*. Writer Hollingsworth! Only under the name: Eugene Tilton."[75]

Harrowing Times

William Hollingsworth experienced his share of love and happiness in his life, but as O. C. McDavid stated, "[his] sensitivity was his burden."[76] The horror of World War II weighed heavily on the artist. On the first of January 1941, Hollingsworth wrote, "Over there—the bombs still fall, ships still go down, men fight, men die—and no-one is yet wise enough to stop it. …How many died in Europe today?????"[77] On Christmas Day of the same year, he recorded that he had secretly sent his qualifications as an artist to the naval commandment in New Orleans. They replied that there was not a need for his services yet. It was difficult to hear the news of the war from afar. On December 31, "I sometimes wish I was, or could, or would, go into the forces and fight and kill and get killed or not killed but get it over with."[78]

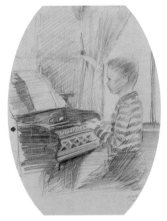

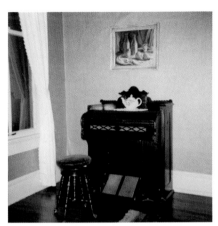

Billy Playing the Organ
April 1940
graphite on paper
7.25 x 5.5 in.
1987.250

Harmonium in dining room in Hollingsworth home, 1950s.

William R. Hollingsworth, Jr., no date.

Billy and Boy, May 1937.

Billy, 1942.

Capitol Street, Jackson, 1940.
Photo © Gil Ford Photography.

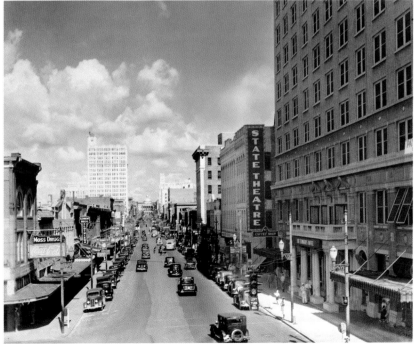

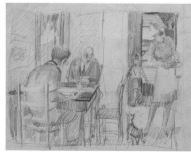

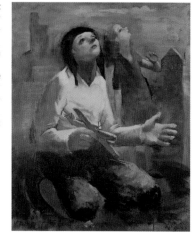

Playing Army
1943
graphite on paper
10.5 x 9.75 in. (sight)
1987.213

Sketches for
Family at Mealtime
from the artist's sketchbook
April 26, 1943
graphite on paper
Courtesy of Mississippi Department
of Archives and History, Jackson

The Alert
December 1942
oil on canvas
32 x 26 in.
1987.030

Family at Mealtime
May 1943
oil on canvas
20 x 16 in.
1987.042

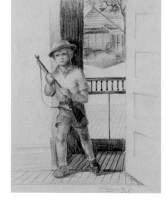

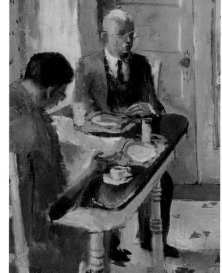

In August 1942, Hollingsworth finally had his chance to join active duty. The newspaper reported, "Business as usual will go on at William Hollingsworth's studio as his wife, Jane, continues to offer his work for sale altho' our artist pal has joined the U.S. Navy and is now in San Diego. Hollie has won much fame for himself and we're betting on him collecting some more as one of Uncle Sam's boys."[79] However by September 28 he was back in Jackson after being dismissed due to poor eyesight, "And so I have had my hitch in Uncle Sam's Navy. …I was given a medical discharge and sent home."[80] A dejected Hollingsworth began to note the war's headlines each day in his journal,[81] and he increasingly addressed the theme of war in his artwork. For example, in a 1943 sketchbook, he has sketched his family in the kitchen. He and his father are reading at the table, Jane is nearby with a plate of food, and son Billy is near a window wearing a soldier costume. On the next page, he has refined the sketch so that Mr. H.'s face is more finished, the newspaper headline clearly contains the word "NAZIS," and Billy's rifle is more prominently displayed. The war infiltrated every aspect of life from newspaper and radio to war bond sales, gas rations, and the newsreels shown before movies.

On June 20, 1943, Hollingsworth suffered the death of his father, friend, and "Rock." It was a loss from which he would never truly recover. He often visited the cemetery and regularly dreamt of his father. He was reminded of Mr. H. in Bible verses and even marked the days since his departure in his diary. Hollingsworth, despite his artistic achievements, was deeply depressed. This was exacerbated by not only the loss of his father, but the trying economic times, the war, and his struggles with alcohol. Before his death, Hollingsworth decided to take his family on a trip together using prize money from the Southern States Art League. They visited Jane's family in Moline, Illinois, during the Fourth of July holiday and went to Chicago before returning home. Hollingsworth wrote about the upcoming visit to Chicago while in Moline, "To live for a few brief hours, the free, carefree life of yesterday. To think of pictures and movies and food and drink and feel the strong pulse of the City once more. To even imagine that it were once-upon-a-time—that, yes, the solid Rock, the Skipper, awaited one back home, that life was all ahead, that genius surely rests in this soul."[82]

Only a few weeks after the family's return from Illinois, William Robert Hollingsworth, Jr., ended the relentless turmoil that he experienced. The *Clarion-Ledger* reported that he shot himself at his home early Tuesday morning, August 1, 1944, leaving a note in which he claimed sole responsibility. He was buried the following morning at Cedarlawn Cemetery in Jackson.[83]

The Legacy of William R. Hollingsworth, Jr.

The first of many tributes to William Hollingsworth was the closing of the Municipal Art Gallery on the day of his burial. Almost immediately, memorial exhibitions were mounted: in September at Findlay Galleries in Chicago, in November at the Brooks Memorial Art Gallery in Memphis and Belhaven College in Jackson. The Municipal Art Gallery held its first memorial exhibition in October and November 1945, which was followed by a *Second Memorial Exhibition* in September 1949 and another memorial show in 1958.

Jane Hollingsworth became the head of the household in the fall of 1944, and a single parent to eleven-year-old Billy. In addition, she became the de facto curator of hundreds of her late husband's works of art, which she meticulously cared for and catalogued. She continued to promote Hollingsworth's artwork until her death in 1986. Her goal was to have one exhibition per year of the work from her collection,[84] and she was close to achieving that goal. The artist's work has appeared in more than fifty exhibitions since his death, many of which were held during Jane's lifetime. As Jane aged, she began to sell or donate her husband's artwork to reputable collections or place it in the hands of individuals she trusted. The largest of these gifts was her bequest of 258 works to the Mississippi Museum of Art, which were officially added to the permanent collection of the institution in 1987.

Mr. and Mrs. Harry J. Hammer, owners of Steele Cottage in Vicksburg, opened their home to the public to showcase Hollingsworth's art on more than one occasion, the first of which was in March 1962 and included about sixty paintings from private collections in a tribute to the artist. The Hammers of New York City (Mrs. Bette Barber Hammer was from Vicksburg and had lived in

Jane Hollingsworth with her brother Robert Oakley and mother Gertrude Oakley, Moline, Illinois, July 4, 1944.

Billy on his eleventh birthday, Moline, Illinois, July 6, 1944.

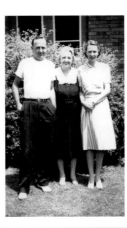

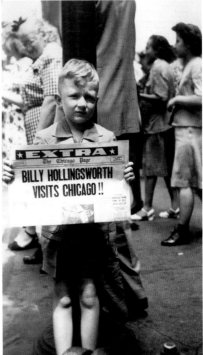

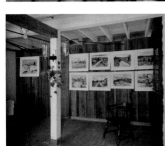

Billy in Chicago, July 1944.

Jane, 1966.
Photo © Hunter M. Cole.

Memorial exhibition at Steele Cottage, Vicksburg, March 1962. Courtesy of Mississippi Department of Archives and History, Jackson.

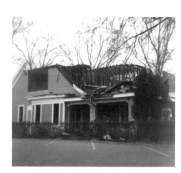

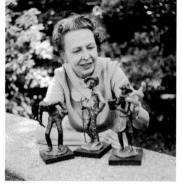

754 North President Street, February 1968.

Jane with three of her bronze sculptures, circa 1977.
Photo © Hunter M. Cole.

Showers with Winds Gusting Up to 40 M.P.H.
1973
bronze
12.25 x 6.75 x 6 in.
Gift of Joe Bennett
2005.020

Municipal Art Gallery, November 1, 1981.

Jackson during the war) also owned the world-renowned Hammer Galleries in New York City. Jane attended the event as guest of honor.[85] A significant exhibition of nearly 200 never-before-seen sketches was held at the grand opening of Jackson's New Stage Theatre in January 1966.[86] Not only was the public able to see the sketches for the first time—and buy them—the exhibition enabled Jane to help boost attendance at the theater, which was outside the city center. Two other exhibitions stand out amongst the others—the first was a solo show in 1981 at the Municipal Art Gallery where the artist spent so many hours in the 1940s, and the second was the result of Jane Hollingsworth's bequest to the Mississippi Museum of Art. That retrospective primarily featured work from the large bequest and ran from May to August 1987.

Admirers of Hollingsworth's art continued to write about his work long after he died. Karl Wolfe wrote poetically about his friend and his artwork. He contributed articles to local newspapers, wrote statements to accompany exhibitions, and even included text about Hollingsworth in his autobiography.[87] Professor and art critic Louis Dollarhide wrote frequently on Hollingsworth's artwork in the 1950s and 1960s, as well as participated in at least one panel discussion on the artist during the Municipal Art Gallery exhibit in 1958.[88] After seeing the same exhibition at the Art Gallery, Eudora Welty was moved to pen an essay about Hollingsworth that appeared in the society section of the *Clarion-Ledger* and in 2002 was published as *On William Hollingsworth, Jr.*[89] O. C. McDavid was a daily news editor and close friend of Jane Hollingsworth. He provided support in promoting her husband's career, and even encouraged Jane's artistic career years later. McDavid is the author of the informative introduction to the book, *Hollingsworth: The Man, the Artist, and His Work*, which included the artist's journal entries, edited by Jane and published in 1981. Hunter M. Cole, of the University Press of Mississippi, edited the Eudora Welty publication on Hollingsworth.

Cole met Jane Hollingsworth through his art teacher Karl Wolfe in the late 1950s, and he and Mrs. Hollingsworth became friends as she shared with him diaries, sketchbooks, and artwork by her late husband, and endless stories. In addition to the afterword for the Welty publication, Cole has written other essays on the artist including "William Hollingsworth: An Artist of Joy and Sadness," an enlightening piece written for the Mississippi Historical Society's website "Mississippi History Now."[90]

Jane continued her career as a designer, working from her studio on the lower floor of the turret in the President Street home. Her mother, Gertrude Melvin Oakley (1889–1968), moved into the Hollingsworth home in Jackson with her daughter and grandson by 1947.[91] After her mother moved to Jackson, Jane worked for the public library as an art specialist, where one of her duties was the compilation of artists' biographies based on a survey she conducted in 1962.[92] To supplement the family's income, Jane rented the top floor of 754 North President Street to tenants, including medical students. After her son moved out, Jane and her mother moved into the house at 907 Euclid Avenue in the Belhaven neighborhood, coincidentally a home that was owned by Mr. H. while he worked in real estate.[93] Following their move, the President Street home was demolished to make way for commercial development. Under the heading "Another Landmark Goes," the *Clarion-Ledger* reported of its demise on March 2, 1968, "The house at North President and Barksdale streets in which the great young artist William Hollingsworth was born and reared, and in which many of his finest art treasures were produced, is giving way to the wrecker's hammer these days."

In the early 1970s, Jane began making a name for herself as an artist. In September 1972, Jane debuted about twenty-five small sculptures she had created over the course of eighteen months at the Mississippi College foundry. The small bronzes were featured

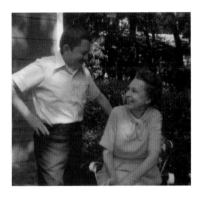

Bill and Jane, May 1979.

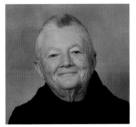

Brother Anselm (William Robert Hollingsworth III), 2009. Photo by Fred Meyer.

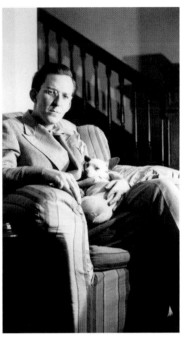

Hollingsworth and his dog Boy, 1937.

in a solo exhibition at the New Stage Theatre gallery. She called the humorous figure studies her "Little People" and the tiny busts "Lead Heads."[94] In September 1974, Jane was included in an exhibition called *6 From Jackson* at the Meridian Museum of Art along with Robert Pickenpaugh, Helen Bryant, Helene Canizaro, Gray Layton, and Jack Jordan.[95] Her sculpture *Showers with Winds Gusting Up to 40 M.P.H.* (1973) is in the collection of the Mississippi Museum of Art. She also enjoyed hand making other items such as cards out of construction paper and dried flowers for her family, and according to friend Hunter Cole she practiced the traditional craft of quilling (arranging curled paper into designs). Celia Jane Hollingsworth passed away on April 20, 1986.

William "Billy" Robert Hollingsworth III grew up in Jackson, attending the same schools as his father, though his middle school years were spent at the newly-constructed Bailey Junior High. There he formed a fifteen-piece band that performed at school dances and later, "The Bill Hollingsworth Orchestra" played at hotels in the Jackson area.[96] After graduating from Central High School, Hollingsworth III worked for a radio station and then Blue Cross Blue Shield for five years before he left Jackson for St. Joseph Abbey in St. Benedict, Louisiana, in 1959. He made his first vows as a brother there in 1960 and his life vows in 1963. In 2010, Brother Anselm (as he is now known) celebrated the golden anniversary of his vows.[97] For forty-nine years at the monastery, Brother Anselm logged the high and low temperatures and the precipitation each day, which he reported to the National Weather Service, and he resigned from this duty in 2009. He was organist at the abbey church for about thirty-five years, and while no longer holding that position, he still plays blues or jazz on the keyboard in his room.[98] In 2011 he received a harmonica as a gift, which he plays on strolls through the abbey's woods.[99]

William R. Hollingsworth, Jr.'s artwork remains relevant, with admirers and scholars continuing to identify with his poetic pieces nearly seventy years after he created the last of them. In a brief thirty-four years, Hollingsworth left a lasting artistic legacy in Mississippi and beyond, through hundreds of paintings, drawings, and sculptures that are in collections across the United States—the largest at the Mississippi Museum of Art in Jackson, with 295. His paintings, particularly the landscapes and genre scenes, transcend time like other masterworks in art, literature, or music. His sensitivity was his burden, but that ability to deeply feel both good and bad surely contributed to the success of his compositions. Hollingsworth was a master at his craft; there is no doubt. However, the artist's sensitivity, observant nature, and capacity to translate local scenes into visual poetry are the intangible qualities with which viewers connect so strongly nearly one hundred years later.

Robin C. Dietrick
Curator of Exhibitions
Mississippi Museum of Art
Jackson

NOTES

1 Karl Wolfe, "William Hollingsworth," Hollingsworth (William) Press Books, Z/1242.000, box 1, Mississippi Department of Archives and History, Jackson, Mississippi [hereafter MDAH].

2 According to "Artist Had Vicksburg Background," *Vicksburg Evening Post*, March 9, 1972, and the 1880 United States Census (Vicksburg, Warren County, Mississippi, page 352B, www.ancestry.com), Willie Belle was the daughter of Isabella and William A. Vanzile. Her father was a clerk in the Warren County Courthouse in 1903, and the family lived on Jackson Street at Third North as early as 1850.

3 Marriage record, William R. Hollingsworth to Willie Belle Vanzile, March 24, 1896, Warren County, MDAH.

4 Robert S. Brown, *History of the Mississippi School for the Deaf*, 1854-1954 (Meridian, MS: Gower Printing and Office Supply Co., [1954]), 24, 46, 48.

5 Floor plans provided to author by Brice Oakley.

6 *The Quadruplane* (1928), Hollingsworth (William) Press Books, Z/1242.000, box 2, miscellaneous yearbooks folder, MDAH.

7 Martha Harrison, "Hollingsworth's Popular Medium Found Overnight," *Jackson Daily News*, October 30, 1938.

8 Tom Etheridge, "Mississippi Notebook," *Clarion-Ledger*, August 31, 1968.

9 Sketchbook (1930), Hollingsworth (William) Photograph Collection, PI/2004.0020, box 575, folder 1, MDAH.

10 Map (Rand McNally and Company, July 1921) from "This Week in Chicago, September 4–September 10, 1921," http://en.wikipedia.org/wiki/File:1921_Chicago_L_map.jpg.

11 Harrison, "Hollingsworth's Popular Medium Found Overnight."

12 1920 United States Census, Moline, Rock Island County, Illinois, page 6A, www.ancestry.com.

13 William Robert Hollingsworth III, e-mail message to author, May 1, 2012.

14 Birth certificate, William Robert Hollingsworth III, July 6, 1933, Division of Vital Records, State of Illinois Department of Public Health (collection of William Robert Hollingsworth III).

15 Harrison, "Hollingsworth's Popular Medium Found Overnight."

16 "Amateur Show Arouses Much Interest Here," newspaper unknown, April 1933, in Hollingsworth (William) Press Books, Z/1242.000, box 2, MDAH.

17 Harrison, "Hollingsworth's Popular Medium Found Overnight."

18 Ibid.

19 Hollingsworth (William) Photograph Collection, PI/2004.0020, box 576, folder 1, MDAH.

20 Suzanne Marrs, "Eudora Welty's Enduring Images: Photography and Fiction," in *Passionate Observer: Eudora Welty Among Artists of the Thirties*, ed. René Paul Barilleaux (Jackson: Mississippi Museum of Art, 2002), 10.

21 The Mississippi Art Association (MAA) was formed in 1911 by members of the Art Study Club, which Bessie Cary Lemly founded in 1903. In 1926, the Gale family donated their home to the city of Jackson and it became the headquarters of MAA shortly thereafter. MAA grew exponentially over the decades from a volunteer organization to become the Mississippi Museum of Art in 1978, when the Museum opened at the Mississippi Arts Center at 201 East Pascagoula Street. In 2007, the Museum relocated to its present location at 380 South Lamar Street. The Municipal Art Gallery remains open to the public and is currently operated by the city of Jackson.

22 Helen Jay Lotterhos, "Water Colors At Clubhouse Are Revived," newspaper unknown, 1934, in Hollingsworth (William) Press Books, Z/1242.000, box 2, MDAH.

23 "Club House Opened For Art Exhibit, Mississippi Art Association Shows Annual Exhibit of Paintings," newspaper unknown, November 5, 1935, in Hollingsworth (William) Press Books, Z/1242.000, box 2, MDAH.

24 "Hollingsworth Exhibit Opens At Art Gallery," *Jackson Daily News*, September 12, 1939.

25 Harrison, "Hollingsworth's Popular Medium Found Overnight."

26 William Robert Hollingsworth, Jr., diary entry in *Hollingsworth: The Man, the Artist, and His Work*, ed. Jane Hollingsworth (Jackson: University Press of Mississippi, 1981), 18 [hereafter *Hollingsworth*].

27 Harrison, "Hollingsworth's Popular Medium Found Overnight."

28 W. R. Hollingsworth, Jr., "Accepted Work Fails To Satisfy Painter, In Spite Of Praise," *Daily Clarion-Ledger* (Jackson), December 4, 1938.

29 Robert D. Harshe to William R. Hollingsworth, Jr., March 17, 1937, in Hollingsworth (William) Press Books, Z/1242.000, box 2, MDAH.

30 Eleanor Jewett, "International Exhibit Stars U. S. Artists," *Chicago Tribune*, March 21, 1937.

31 Harrison, "Hollingsworth's Popular Medium Found Overnight."

32 C. J. Bulliet, "Around the Galleries," *Chicago Daily News*, October 8, 1938.

33 "Whitney Gallery Invites Exhibit By Artist Here," newspaper unknown, 1938, in Hollingsworth (William) Press Books, Z/1242.000, box 2, MDAH.

34 O. C. McDavid, introduction to *Hollingsworth*, 11.

35 Frances Bryson, "Superb Watercolors, Prints, Oils, Etchings and Other Fine Works in New Delgado Show," *Sunday Times-Tribune* (New Orleans), September 29, 1940.

36 *Hollingsworth*, 23.

37 Federal Works Agency Public Building Administration to William R. Hollingsworth, Jr., May 5, 1941, in Hollingsworth (William) Press Books, Z/1242.000, box 1, MDAH.

38 *Hollingsworth*, 24, 25, 34, 36.

39 Mrs. W. Q. Sharp to William R. Hollingsworth, Jr., April 9, 1942, in Hollingsworth (William) Press Books, Z/1242.000, box 1, MDAH.

40 *Hollingsworth*, 36.

41 "Southern States 1st Art Prize Goes to Hollingsworth," *Jackson Daily News*, 1942, in "Hollingsworth, William R. Jr.," Subject File, MDAH.

42 Will Price to William R. Hollingsworth, Jr., November 25, 1942, in Hollingsworth (William) Press Books, Z/1242.000, box 1, MDAH.

43 "Another Hollingsworth Goes To Hollywood," *Jackson Daily News*, January 17, 1943.

44 *Hollingsworth*, 65.

45 Eleanor Jewett, *Chicago Sunday Tribune*, April 11, 1943.

46 *Jackson Daily News*, April 25, 1943, in Hollingsworth (William) Press Books, Z/1242.000, box 1, MDAH.

47 *Hollingsworth*, 67.

48 Eleanor Jewett, *Chicago Sunday Tribune*, October 10, 1943.

49 *Hollingsworth*, 95, 99.

50 Ibid., 116, 117.

51 William Hollingsworth, "Monroe Sketch Exhibit To Be Shown Last Time on Sunday," *Daily Clarion-Ledger* (Jackson), April 13, 1940.

52 *Hollingsworth*, 34.

53 See David Fredenthal (1914–1958), *Colorado*, undated, watercolor on paper, collection of Mississippi Museum of Art, Jackson, 1943.001.

54 *Hollingsworth*, 63.

55 McDavid, introduction to *Hollingsworth*, 10.

56 "Hollingsworth to Head Art Department," *Jackson Daily News*, September 5, 1941.

57 *Hollingsworth*, 27, 35.

58 Ibid., 29, 30.

59 Ibid., 32.

60 Ibid., 19, 22, 45.

61 Ibid., 64, 71, 113.

62 Ibid., 112.

63 Ibid., 21, 22, 134.

64 William Robert Hollingsworth, Jr., unpublished diary entry, November 21, 1940, private collection.

65 William Robert Hollingsworth III, e-mail message to author, May 1, 2012.

66 Hunter Cole, interview with author, January 27, 2012.

67 William Robert Hollingsworth III, e-mail message to author, May 1, 2012.

68 William Robert Hollingsworth, Jr., unpublished diary entry, February 17, 1943, private collection.

69 Ibid., February 20, 1943.

70 William Robert Hollingsworth III, e-mail message to author, May 1, 2012.

71 *Hollingsworth*, 96, 105.

72 William Robert Hollingsworth, Jr., unpublished diary entries, January 6, 1941, January 20, 1942, and March 26, 1943, private collection.

73 Ibid., January 6, 1943.

74 William Robert Hollingsworth III, e-mail message to author, May 1, 2012.

75 William Robert Hollingsworth, Jr., unpublished diary entry, February 10, 1943, private collection.

76 McDavid, introduction to *Hollingsworth*, 12.

77 *Hollingsworth*, 25.

78 William Robert Hollingsworth, Jr., unpublished diary entry, December 31, 1941, private collection.

79 "Tattletale," *Jackson Daily News*, September 6, 1942.

80 *Hollingsworth*, 36.

81 Hunter Cole, interview with author, January 27, 2012.

82 William Robert Hollingsworth, Jr., unpublished diary entry, July 1944, private collection.

83 "Noted Jackson Artist Kills Himself Here; Final Rites Today," *Clarion-Ledger* (Jackson), August 2, 1944.

84 Hunter Cole, interview with author, May 11, 2012.

85 "Hollingsworth Paintings—Memorial Art Exhibition Today At Steele Cottage," *Vicksburg Post*, March 25, 1962.

86 Kay Haggerty, "Hollingsworth Works Get First Public Showing," *Clarion-Ledger* (Jackson), January 16, 1966.

87 See Karl Wolfe, *Mississippi Artist: A Self-Portrait* (Jackson: University Press of Mississippi, 1979), 54.

88 Jan Horton, "Panelists 'Translate' Hollingsworth Works," *Jackson Daily News*, September 18, 1958.

89 Eudora Welty, *On William Hollingsworth, Jr.* (Jackson: University Press of Mississippi, 2002).

90 Hunter Cole, "William Hollingsworth: An Artist of Joy and Sadness," *Mississippi History Now* (November 2005), *http://mshistory.k12.ms.us/articles/37/william-hollingsworth-an-artist-of-joy-and-sadness*.

91 1947 Jackson city directory, www.ancestry.com.

92 Louis Dollarhide, "Artists of Mississippi Numerous, Distinguished," *Clarion-Ledger* (Jackson), August 11, 1963.

93 William Robert Hollingsworth III, e-mail message to author, May 1, 2012.

94 O. C. McDavid, "First Showing of Hollingsworth Sculpture," *Clarion-Ledger* (Jackson), September 24, 1972.

95 *6 From Jackson* exhibition announcement, Meridian Museum of Art (1974), private collection.

96 Terri Landry, "North Shore Stories: Weathering a good and interesting life," *St. Tammany* (LA) *Farmer*, November 19, 2009.

97 William Robert Hollingsworth III, e-mail message to author, May 1, 2012.

98 Landry, "North Shore Stories."

99 William Robert Hollingsworth III, e-mail message to author, May 1, 2012.

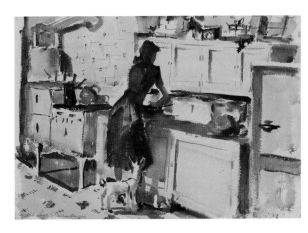

Christmas Eve
December 24, 1942
watercolor on paper
15.63 x 22.5 in.
1987.029

A Sense of Time and Place in Mississippi:

Reconsidering the Art and Life of William Hollingsworth, 1910–1944

J. Richard Gruber, Ph.D.

Three in a Wagon
December 29, 1941
watercolor on paper
18 x 22 in.
1987.018

We here, of course, recognize with ease the material William Hollingsworth worked with, for he always began with the close-at-hand; and the accuracy of his eye, turned on the home scene, is as marvelously reliable as that of another Mississippi William in another line of work. Again like Faulkner he never stops there. William Hollingsworth set off on the Old Canton Road, and the painting is where mind, spirit, and feeling carried him.

—EUDORA WELTY, 1958[1]

Fourteen years after the artist's death, following her viewing of William Hollingsworth's memorial exhibition at the Jackson Municipal Art Gallery, Eudora Welty described in the local *Clarion-Ledger* her fellow Mississippian's ability to capture "the close-at-hand," praising the "accuracy of his eye" in painting "the home scene." As one of the nation's most significant writers, known for her keen and intuitive sense of observation, as well as an accomplished photographer, Welty certainly knew Mississippi. She also knew Hollingsworth and his subject matter. They were born a year apart in Jackson (Welty in 1909, Hollingsworth in 1910); they grew up in the same neighborhoods and attended the same schools (Davis School and Central High School); and both, reluctantly, returned to Jackson, and to the South, to begin their professional careers during the Great Depression.[2]

Eudora Welty's praise of Hollingsworth's art was not slight, nor was it a polite affectation. She knew many of the subjects, landscapes, urban environments, and people—both black and white—that he knew, living in the same segregated world of Mississippi during the first half of the twentieth century. She knew the Farish Street area in Jackson, the African American neighborhood that Hollingsworth painted, and where she also photographed.[3] She knew "the Old Canton Road" that Hollingsworth traveled with his fellow artist, Karl Wolfe because she traveled there herself to sketch the countryside, accompanied by her friend and fellow artist, Helen Jay Lotterhos.[4] She traveled and documented the Mississippi that William Faulkner also knew, living and writing in nearby Oxford, where Hollingsworth first studied art at the University of Mississippi.[5] No doubt, she was conscious of the weight her reference to "another Mississippi William" added to her praise of Hollingsworth's art.

Welty, generously, and wisely, raised the stature of William Hollingsworth in 1958 by comparing his artistic accomplishment to that of William Faulkner—Mississippi's most respected living writer and winner of the Nobel Prize in 1949. In doing so, she elevated Hollingsworth into the creative realm she shared with Faulkner,

as internationally significant artists who, despite their opportunities to live elsewhere, chose to live and work in Mississippi, one of the nation's poorest and most maligned states. It was a place some vilified as a Deep South center of racism, poverty, and limited education. Welty lived in New York for extended periods during the 1930s and continued to visit the city throughout her career as a respected member of its literary world. Before World War II she witnessed the rise of the American Scene and "regionalist" art movements in the city, and she watched as Abstract Expressionism, the "New York School," became the dominant reality of the 1950s art world.[6] Accordingly, she understood that in 1958, when she wrote this essay, Hollingsworth's Mississippi paintings and subjects might seem prosaic, even outdated, to New York art critics.

During the peak of his career, however, in the decade from 1934 to 1944, the art of William Hollingsworth achieved significant national recognition and numerous awards. Beginning with his art studies in Chicago (1930–1934), continuing into his last years in Jackson (1934–1944), until the time of his death in 1944 at the age of thirty-four, Hollingsworth explored what Welty described as a "most personal vision."[7] Hollingsworth advanced a professional career—as an artist, teacher, writer, and arts administrator—during one of the most challenging eras in American history. During these years, Thomas Hart Benton, John Steuart Curry, and Grant Wood were described as leading "regionalist" artists in the nation's art press. All had established significant reputations in New York and the larger art world, and after studying in Paris, returned by choice to live and work in their native Midwestern states, when Hollingsworth returned to Mississippi.

The Depression impacted the evolution of art and culture in Mississippi in notable ways. It brought Hollingsworth and his young wife, Jane Oakley Hollingsworth, from Chicago back to Jackson, directing his focus on the state and its emerging arts scene. In fact Hollingsworth would have preferred to remain in Chicago's more urbane cultural environment. In Jackson, he joined a small

Old Canton Road
1943
watercolor on paper
22 x 30 in.
1987.049

but significant group of Mississippi artists and writers—all at the beginning of their careers—including Welty, Karl Wolfe, and Helen Jay Lotterhos. Wolfe and Lotterhos graduated from the Art Institute of Chicago like Hollingsworth, and Welty attended the University of Wisconsin. Welty, Wolfe, and Lotterhos returned to Jackson in 1931 and Hollingsworth came back three years later. Established older artists like Marie Atkinson Hull and Bessie Cary Lemly were still active in Jackson, while younger artists including John McCrady, Walter Anderson, Dusti Bongé, and Caroline Compton were working elsewhere in the state.[8]

There was, for both Hollingsworth and Welty, a notable change in association with their state after they returned and in their perceptions and appreciation of its unique qualities. Hunter Cole has referred to this change in the two Jackson natives: "Locked in Jackson by hard times and the war years, Hollingsworth, Welty, and their art became rooted. With new eyes they perceived the essence of a setting that sweetened the imagination." Continuing, Cole suggests an important new reality. "In Mississippi, both were struck by a serendipitous windfall—a sense of place and the understanding of what place can teach an artist. Home once had seemed too oppressively familiar, yet now it was new, mysterious, and evocative as an intimate resource for art."[9]

During the decade from 1934 to 1944, Hollingsworth created an extensive body of work and a distinctive chronicle of life in Jackson and the state of Mississippi. He traveled across the state by car (even while gas was rationed during World War II), sketching and painting what he discovered as the Depression era evolved into the war years. His subjects included the modern urban environment, the agrarian landscape, the still life, the human figure, contemporary portraits, and images of family. He documented African American life, including the segregated history and culture of his state, in significant ways. After his return from Chicago, Hollingsworth became an accomplished regional artist—while working in Mississippi's largest city—one who achieved national recognition for his work.

In 1934, then, William Hollingsworth returned to fertile ground, to a state that nurtured some of the most creative visions of his generation. The appreciation of his art has enjoyed a limited

regional revival in recent decades, as the importance of Southern art achieves new stature, yet Hollingsworth's significance remains unappreciated on the national level. In addition to his early death and the brevity of his professional career, he suffered a fate similar to that of many American artists after World War II, especially those categorized as American Scene or "regionalist" painters, when Abstract Expressionism and its advocates rejected these artists' accomplishments as outdated and "provincial."

This essay will reconsider the life and the art of William Hollingsworth, placing him within the larger context of the local, regional, and national art world of his time, reflecting contemporary scholarship and an enhanced understanding of the cultural environment of the South. It will also consider national issues related to Regionalism, the "regionalist" and American Scene movements, and the role of the federal government in the advancement of art and culture during this era. In exploring these issues, it may be possible to understand more fully what Eudora Welty saw in 1958 when she wrote, "We see again as we visit these paintings that his was the quietest of techniques, and the most affirmative. He knew what he saw, and here it is not the copy of life, but visible through his transparent honesty, his vision of it."[10]

October—Gray Light Over Harvest
no date
watercolor on paper
15 x 22 in.
1987.066

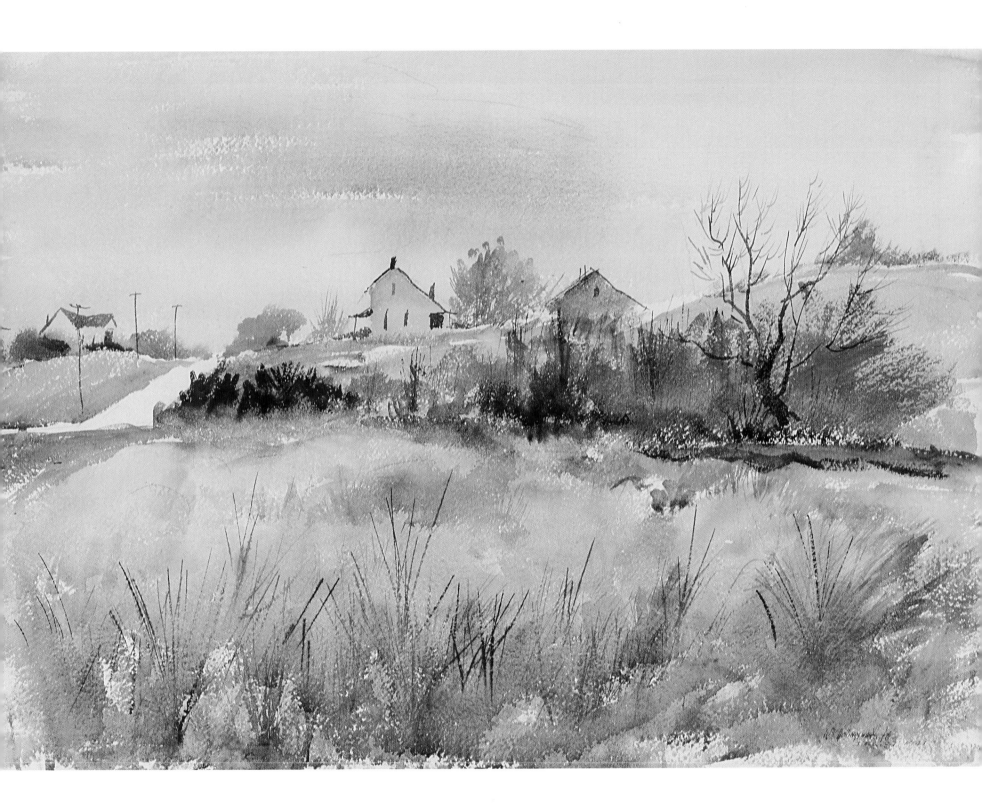

Jackson and Oxford

1910 to 1929

William R. Hollingsworth, Jr., was born on February 17, 1910, the son of William Robert Hollingsworth (1865–1943) and Willie Belle Vanzile (1874–1910), at the family home in Jackson, located at 754 North President Street.[11] As indicated by O. C. McDavid, "William Robert Hollingsworth, Sr. met and married Willie Belle Vanzile, an artist in watercolors and china painting, in Vicksburg, Mississippi. They lived in Chicago for awhile [sic] where Mr. H. (as he was commonly called) was employed and a daughter, Isabel, was born. They moved to Jackson in 1898 and Mr. H. went into the real estate business."[12] The younger Hollingsworth, known as "Hollie," might have benefited from his mother's skills in china and watercolor painting, yet this was not to be. She died ten months after his birth. After her death, Hollingsworth was raised by his father and sister, Isabel, who was thirteen years older.

The city of Jackson enjoyed a population boom around the time of his birth, growing from a city of about eight thousand residents in 1900 to over twenty-four thousand residents by 1910. Downtown Jackson evolved into a center for offices, department stores, movie theaters, churches, the state capitol, and related government structures.[13] In 1938, writers for the WPA Federal Writers' Project described this modern city:

> Jackson (294 alt., 48,282 pop.)...is Mississippi's largest city. Viewed from an upper story window of an office building it is an unconsolidated city of breadth and space...On the south, well-spaced civic buildings surround a block-long flower garden. Near the center, the Governor's mansion, occupying an entire block, looks out upon the business district from a lawn that is wide and shaded with trees. The business district, confined almost exclusively to Capitol Street and characterized by modern façades, is unbegrimed and fresh. To the north and west are the residential districts. The northern section contains a few examples of ante-bellum architecture; the western area is a heterogeneous group of bungalows and English cottages. Strung along the railroad tracks northwest of the business district are the "heavy" industries, lumber, oil, and cotton. Forming concentric ellipses around the north, west, and south edges of the city are new subdivisions. Planted along the neutral grounds and in the city parks are more than 7,000 crape-myrtle trees, Jackson's loveliest natural attraction.[14]

William Hollingsworth's father benefited from, and contributed to, the city's economic and real estate boom through his firm, Hollingsworth and Tyson Real Estate, which he operated with Fred A. Tyson, his son-in-law. Their offices were located in the downtown Merchants Bank and Trust Building, itself a modern symbol of the city's prosperity. One of his major projects was the development of Belhaven, one of the state's most prominent residential districts.[15] Eudora Welty (1909–2001) and her family moved to Belhaven in the 1920s, building a house at 1119 Pinehurst Street where she spent most of her life as an author. Her home is now preserved as a museum, The Eudora Welty House.[16]

The Hollingsworth family home on North President Street was itself an historic property in the old part of downtown, one that his father had converted into a distinctive residence. Hunter Cole has described the Hollingsworth home and its neighborhood. "Before Hollie's birth, his father had bought the North President Street house from the Mississippi School for the Deaf and made it a residence. A large dwelling with high ceilings and a two-story octagonal tower surrounded by a semi-circular porch, it was situated a few blocks north of the state capitol and adjacent to North State Street, an avenue lined then with imposing mansions and elegant lawns, the house was demolished in the 1960s."[17]

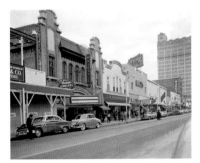

Capitol Street, Jackson, Mississippi, 1940s. Photo © Gil Ford Photography.
Hollingsworth family home at 754 North President Street, Jackson, 1960.

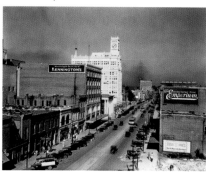

Jackson, 1925.
Photo © Gil Ford Photography.

Capitol Street, Jackson, 1920s.
Photo © Gil Ford Photography.

William Hollingsworth grew up in unique circumstances in Jackson, in a manner that shaped his art as well as his perspectives on life in the state of Mississippi. He matured without a mother, raised by his father and older sister, in a distinctive historic property that had served as a School for the Deaf, in a neighborhood in the heart of downtown, with access to all that the thriving state capital of Mississippi offered a young man. After attending Davis School (the same school as Welty), located only a block away, he graduated to Central High School. During these years, he developed an understanding of the city that would inform his mature art forms, as well as his awareness of its people and its culture. In many ways, despite Jackson's urban context, his formative experiences seem to more closely resemble those of the mythic, small-town ideals found in the popular literature and films of this era. Hunter Cole has described his Jackson environment. "Smith Park and the First Baptist Church, which the Hollingsworths attended, were nearby. Downtown Jackson was a short stroll from the Hollingsworth residence. So young Hollingsworth's world of school, church, movie houses, and parks was cozy and confined."[18]

Underscoring this, Hollingsworth's early years share similarities with those described by Eudora Welty, including her own references to the same neighborhoods, the same schools, and her urban experiences in downtown Jackson. She played in Smith Park, participated in family picnics, and attended evening band concerts there. She too enjoyed exploring downtown Jackson with her friends, as she described. "Setting out in the early summer afternoon on foot, by way of Smith Park to Capitol Street and down it, passing the Pythian Castle with its hot stone breath, through one spot of shade beneath Mrs. Black's awning, crossing Town Creek—then visible and uncontained—we went carrying parasols over our heads and little crocheted bags over our wrists (with a nickel or dime further for McIntyre's Drug Store after the show), and we had our choice—the Majestic or the Istrione."[19] Welty took art classes with Marie Hull, studied piano and dance with local instructors, and walked to the public library, where she bristled at the restriction imposed by the librarian, Miss Annie Parker, limiting her to checking out only two books a day.

The lifestyle of the Hollingsworth family, like that of the Weltys, reflected the manners and mores of the middle and upper classes of Mississippi, including those who had profited in significant ways from the postwar economic boom. That boom spiraled upward during the 1920s, an era known for seemingly unchecked (and loosely regulated) business, real estate, and economic growth, fueling new levels of prosperity and luxury for many, including those in the South's major cities. As a real estate agent and developer, Hollingsworth's father worked with the middle and upper classes, expanding their life styles and images as reflected in the success of neighborhoods like Belhaven. Eudora Welty's father—a member of the board of directors, as well as a manager and vice president of Jackson's thriving Lamar Life Insurance Company in the 1920s—was placed in charge of the construction of Jackson's first skyscraper. Reflecting his stature, he hired the same architect to design his family's house in Belhaven.[20]

Before the stock market crash of 1929 and the Great Depression that followed, new wealth was enjoyed by a diverse range of Jackson residents, yet others lived, often nearby, in a manner that appeared far removed by both race and class, even when the geographic divide was only a matter of blocks. Writers for the WPA guide to Mississippi reported that approximately "40 percent of the population are the Negroes who furnish the bulk of the city's unskilled labor," many of them living "in the northwest section, in three- and four-room frame houses." A common symbol that reflected the crossing of race

Town Creek
1942
watercolor on paper
15 x 22 in. (sight)
Collection of Robin and Norwood Smith, Jackson, Mississippi

and class lines was noted by these writers. "More familiar than the garden, however, is the clothes line upon which hangs the week's washing of some white family. For Jackson has not yet abandoned its washerwomen in preference to laundries, and many Negro women, who often are employed as cooks and nursemaids, take in washing on the side."[21]

In their early recollections, Hollingsworth and Welty make little mention of the Farish Street area, the thriving hub of Jackson's African American community, though it was only a short walk from their childhood homes. However, after they returned to Jackson in the 1930s, after experiencing the diverse, complex, and rich cultural life of northern cities (Chicago for Hollingsworth; Madison, Chicago, and New York for Welty), they began to document those who worked, worshipped, and were entertained there. Writers for the WPA project made particular note of Farish Street, pointing out that it was more than a shopping district. "Farish Street is the spinal cord of the Negro business district...On Saturday nights this street, swarming with shoppers and pleasure seekers, has a carnival atmosphere. The shingles of Jackson's Negro lawyers and doctors compete with lodge signs...the Negro social life, for the most part, is confined to the picture shows, dance halls, and pool rooms on or near this street."[22]

During the 1920s, another major American literary figure, an African American writer, experienced a different side of life in Jackson. Richard Wright (d. 1960) was born on September 4, 1908 near Roxie, Mississippi, and was close in age to Welty and Hollingsworth, yet all four of his grandparents had been born into slavery, making his life in segregated Mississippi quite different than theirs. Moving often with his family, Wright arrived in Jackson, enrolled in Jim Hill School in 1921, and found a job as a newsboy. Wright was barred from entering the segregated public library and was denied access to many of the public facilities enjoyed by Welty, Hollingsworth, and their peers. In 1923, he entered Jackson's Smith-Robertson Junior High School and graduated as its valedictorian in 1925. That fall he enrolled in Lanier High School, but dropped out to work, then moved to Memphis where he remained until he moved to the South Side of Chicago in 1927.[23]

Wright described his Jackson years in *Black Boy*, published in 1945 (the year after Hollingsworth's death). He lived in his grandparent's house and began writing at a young age, publishing a story in a black paper, the *Southern Register*. Yet he wanted more, despite the odds (and the laws) against him. "I dreamed of going north and writing books, novels...I was feeling the very thing that the state of Mississippi had spent millions of dollars to make sure that I would never feel; I was becoming aware of the thing that the Jim Crow laws had been drafted and passed to keep out of my consciousness...I was beginning to dream the dream that the state had said were wrong, that the schools had said were taboo." Though young, he began to consider his place in the Great Migration. "I was in my fifteenth year; in terms of schooling I was far behind the average youth of the nation, but I did not know that. In me was shaping a yearning for a kind of consciousness, a mode of being that the way of life about me had said could not be, must not be, and upon which the penalty of death had been placed."[24]

Wright moved to Chicago and later wrote that he was "not leaving the South to forget the South, but so that some day I might understand it." Despite the racial and social limitations placed upon him, he deeply identified with the region. "I could never really leave the South, for my feelings had already been formed by the South, for there had been slowly instilled into my personality and consciousness, black though I was, the culture of the South."[25]

Hollingsworth's life was considerably different than Wright's even though they lived during the same years, in the same city. Hollingsworth's father was highly supportive (remarkably so, for this era in Southern history) of his son's artistic ambitions. In high school, when he stated that he wanted to become a cartoonist, his father paid for a cartooning correspondence course, at the not insignificant fee of twenty-five dollars. A few of his cartoons were published in Jackson newspapers. During his senior year in high school, he and his father made a weeklong trip to Chicago, where they visited the noted Chicago cartoonist, Carey Orr. Young Hollingsworth showed Orr examples of his work, and asked for advice on training and a career. Orr recommended he attend an art school and learn how to draw, as well as study history and English,

to aid in his pursuit of a career as a professional cartoonist.[26]

Hollingsworth and Welty, like other white students at Central High enjoyed the benefits of a good public education. Welty's biographer, Suzanne Marrs, discovered a range of significant achievers in their classes of the 1920s. "Not only did Jackson [Central] High students come from such divergent backgrounds, many also went on to lead notably accomplished lives. Among Welty's friends who graduated between 1923 and 1928 were an artist (Helen Jay Lotterhos), a composer ([Lehman] Engel), two college professors (Frank Lyell and Bill Hamilton), a journalist (Ralph Hilton), a lawyer (Joe Skinner), and Episcopal priest (George Stephenson), and a *New York Times Book Review* editor (Nash Burger).[27] Hollingsworth's own experiences there indicate that he was well prepared for his college and art school experiences, first in Oxford, then in Chicago.

Following his graduation from Central High School in 1928, Hollingsworth enrolled at the University of Mississippi, then a segregated public university known as a citadel for the children of the state's white middle and upper classes. Even ten years after his arrival in Oxford, during the last years of the Depression, writers for the WPA could describe the town as marked by "the persuasive charm and culture of the Old South." Oxford's setting was described in genteel terms. "Cloistered behind the cedar, magnolia, and oak trees along these streets are the homes that make Oxford today seem as it has always been, a town dedicated to the culture and social life revolving around the university." By then the town had become the well-known home and subject of writer William Faulkner (1897–1962), whose 1848 Greek Revival house, "Rowan Oak," was illustrated in the 1938 guide.[28]

Oxford offered a transition from the urban life and faster pace of Jackson, yet it reflected the comfortable life and smaller cultural community Hollingsworth knew there, as suggested by the WPA writers. "Tradition is important; the current of Oxford's life is not swift, but deep. The people are not prosperous as in the days 'before the war,' but they are comfortably sustained by the university and by the farmers who come in on Saturdays to do business on the square."[29] During his two years of study there in 1928 and 1929, Hollingsworth pursued his cartooning interests, sharing them with his friends and publishing some of his cartoons in the *Ole Miss*, the university yearbook.

While Hollingsworth was at Ole Miss, the artist Thomas Hart Benton (1889–1975) made his way from New York through Mississippi to Louisiana as part of his ongoing exploratory trips through the nation's heartland, into the Appalachian Mountains, the Deep South, and along the Mississippi River. In Mississippi, he experienced the realities of the state in his own way, at his own pace, sketching, observing, and taking notes, which would later be used in his popular autobiography, *An Artist in America* (1937). Benton observed daily life in the state, including cotton farming, and sketched antebellum architecture in Natchez, traveled the Mississippi River down to New Orleans, then worked his way back to New York, after sketching in the sugar cane fields and farmlands of Louisiana. His sketches and wide range of experiences in a changing America inspired the ambitious subject matter of Benton's first major public mural cycle, *America Today*, completed in 1930 for the New School for Social Research in New York. In these murals, Benton incorporated scenes he had witnessed and sketched in Georgia, Mississippi, Louisiana, and across the South.

Chicago

1930 to 1934

In 1930, after two years at Ole Miss, Hollingsworth's father offered to support his continuing artistic education by paying his tuition and fees at the School of the Art Institute of Chicago, one of the most prominent art schools in the country. Chicago was a city with special history and meaning for Hollingsworth and his family. It was also a major destination for many from the state of Mississippi. He first traveled to Chicago during high school with his father, who had arranged an introduction to cartoonist Carey Orr. Now the young Hollingsworth had returned, to advance the art studies recommended by Orr. His father knew Chicago well—it was the city where he and his young wife, Willie Belle Vanzile, moved after their marriage in Vicksburg. Their oldest child, his sister Isabel, was born there and spent her early years in Chicago. In many ways, Chicago had offered the foundation for this young family before they moved to Jackson in 1898.

Chicago was a thriving metropolis, one very different from Jackson, when Hollingsworth arrived there. It was known as the "Second City," competing with New York. By then it was recognized for many things including its architecture and architects (H. H. Richardson, Daniel Burnham, Louis Sullivan, Frank Lloyd Wright), including its towering skyscrapers; Lake Michigan and its lakefront development; State Street, Michigan Avenue, and the downtown Loop; ethnic populations and their diverse cultures and neighborhoods; jazz and blues; vaudeville theaters and movie palaces; its role as a "Black Metropolis"; organized crime, Alphonse Capone, and the St. Valentine's Day massacre; major media outlets including radio stations (WGN, WCFL, WEDC) and newspapers (*Chicago Daily News*, *The Chicago Defender*); the Chicago Cubs; and a rich cultural environment including its museums, opera house, symphony hall, theaters, universities, and educational institutions.[30]

One of the dominant cities in the Midwest, Chicago attracted many people from Mississippi, both black and white. It was also a major northern city easily reached by rail, encouraging countless African Americans to leave Mississippi and the South in the Great Migration, as John Barry discovered in his study of the Mississippi River Flood of 1927. "During World War I 'the Great Migration' began; the South lost 522,000 blacks between 1910 and 1920, mostly

between 1916 and 1919. Now from the floodplain of the Mississippi River, from Arkansas, from Louisiana, from Mississippi, blacks were heading north in even larger numbers. In the 1920s, 872,000 more blacks left the South than returned to it." And, as Barry learned, the "favorite destination for Delta blacks was Chicago." They contributed to the black population explosion there, "from 44,103 in 1910 to 109,458 in 1920—and 233,903 in 1930." Barry offered his conclusion, "And even within that alluvial empire, the great flood of 1927 was hardly the only reason for blacks to abandon their homes. But for tens of thousands of blacks in the Delta of the Mississippi River, the flood was the final reason."[31]

Hollingsworth's move to Chicago took place as these larger changes were developing across the nation. His reasons for moving were artistic, rather than social, but his experiences in Chicago, and later in Mississippi, focused his attention on one of the major events of the last century, the Great Migration. As Isabel Wilkerson recently documented in *The Warmth of Other Suns: The Epic Story of America's Great Migration*, this migration continued for decades. "It would become perhaps the biggest underreported story of the twentieth century. It was vast…Over the course of six decades, some six million black Southerners left the land of their forefathers," in a process that continued past the Civil Rights era. "The Great Migration would not end until the 1970s, when the South began finally to change—the whites-only signs came down, the all-white schools opened up, and everyone could vote. By then nearly half of all black Americans—some forty-seven percent—would be living outside the South, compared to ten percent when the Migration began." In Chicago, Hollingsworth's art began to document this shift because his work was populated with more African American subjects. "In Chicago alone, the black population rocketed from 44,103 (just under three percent of the population) at the start of the migration to more than one million at the end of it. By the turn of the twenty-first century, blacks made up a third of the city's residents, with more blacks living in Chicago than in the entire state of Mississippi."[32]

After arriving in Chicago, Richard Wright wrote about the city, his perspectives as a black man there, and how it compared to living in Mississippi (recording different experiences, in yet another city,

than those of Hollingsworth). He wrote about his first impressions of Chicago in *Black Boy*. "The train rolled into the depot. Aunt Maggie and I got off and walked slowly through the crowds in the station. I looked about to see if there were signs saying: FOR WHITE— FOR COLORED. I saw none. Black people and white people moved about…There was no racial fear." While waiting for a streetcar, he noted the realities of his new environment. "I looked northward at towering buildings of steel and stone. There were no curves here, no trees; only angles, lines, squares, bricks and copper wires… Streetcars screeched past over steel tracks. Cars honked their horns. Clipped speech sounded about me."[33]

Wright and Hollingsworth existed in different spheres in Chicago, as they had in Jackson, yet it was important for Hollingsworth to experience the way black and white cultures lived and mixed there. He gained a more northern perspective on relationships between blacks and whites, one understood by his future wife, Jane Oakley. It was certainly different than what he had encountered in Jackson and in segregated campus life at Ole Miss. When he returned to Jackson and connected with Welty, Wolfe, Lotterhos, and others who had been to Chicago and New York, they all looked at black life in different ways. Hollingsworth developed a new appreciation for the Farish Street neighborhood and the black districts that became increasingly central to his creative life in his last years, from 1934 to 1944. In Chicago, then, Hollingsworth accomplished what many of his contemporaries did when they traveled to Paris during the 1920s seeking artistic freedom and inspiration as well as new perspectives on their native land.

The move to Chicago also gave him access to one of the country's major art museums, a resource he did not have in Jackson, though he visited the Delgado Museum of Art in New Orleans and the Brooks Memorial Art Gallery was in nearby Memphis. At the Art Institute he studied art history, life drawing, landscape, still life, and painting the figure in oils and watercolors. He became fond of his life drawing classes and often carried a paper and pad around Chicago. In the streets he regularly observed and sketched images of a city known for its complex layers of ethnic culture and mix of working classes and urban sophisticates. Hollingsworth filled his sketchbooks with Chicago street scenes, reflecting his ongoing education in this major

metropolis. These observations and experiences honed his eye and skills—later he would apply the same techniques of observing and sketching on the streets of Jackson—broadening his appreciation of twentieth century urban life, and preparing him for a professional career as an artist in Jackson.

Hollingsworth arrived in Chicago at a critical juncture in the evolution of that city's art world and that of the nation. Chicago, more than New York, may have been the ideal place for Hollingsworth to study art in these years because the emerging American Scene and "regionalist" movements were inspiring a new appreciation for the American heartland and its potential for a new direction in American art, as the Depression era unfolded and the call for more "American" art forms advanced. This was amplified by his family's history and connections to the city. In fact, during the four years he studied in Chicago, he was located near the center of many evolving developments in the American art world including the emergence of Grant Wood (1891–1942) from nearby Iowa, the increasing presence and profile of John Steuart Curry (1897–1946) and Thomas Hart Benton in the region, as well as being there at the time of the building and opening of the Century of Progress Fair in 1933.

When Hollingsworth arrived in Chicago in 1930, Grant Wood was working in Cedar Rapids, Iowa, after studying at the School of the Art Institute of Chicago and at the Académie Julien in Paris. In 1928, after working in Munich and supervising the production of his stained glass window project for a building in Cedar Rapids, Wood returned to Iowa and began a series of major works including *Woman with Plants* (1929), *Stone City* (1930), and *American Gothic* (1930). *American Gothic* won the Norman Walt Harris Medal in 1930 at the *Forty-Third Annual Exhibition of Painting and Sculpture* at the Art Institute of Chicago and was purchased by the Institute, making it available to Hollingsworth throughout his time there. In 1931, Wood exhibited *The Midnight Ride of Paul Revere* at the Art Institute and his *Daughters of Revolution* (1932) was shown at the new Whitney Museum in New York the next year. In 1932 he served as a founder of the Stone City Colony and Art School in Iowa, where in 1933 John Steuart Curry was a guest teacher. That year Wood also exhibited a five-panel mural painting at the Century of Progress Exposition. In 1934, Hollingsworth's final year in Chicago, Wood became Director

Sketches of downtown Chicago
from the artist's sketchbook
1932
graphite and ink on paper
Courtesy of Mississippi Department of Archives and History, Jackson

Passing People, State at Monroe
from the artist's sketchbook
1930
graphite on paper
Courtesy of Mississippi Department of Archives and History, Jackson

of the Public Works of Art Project in Iowa, was appointed Associate Professor of Fine Arts at the University of Iowa, and met Thomas Hart Benton and Thomas Craven on a trip to New York.[34] During these years, Grant Wood became an outspoken advocate for the value of art produced in the heartland of the country. This was a primary reason for founding the Stone City Art Colony which was short-lived, surviving only for the 1932 and 1933 seasons.

At this time, both Thomas Hart Benton, a Missouri native, and John Steuart Curry, a Kansas native, lived in the East—Benton in New York City, Curry in Bridgeport, Connecticut. Benton had traveled, sketched, and studied the diverse regions of the country since the early 1920s, using those studies and experiences to inspire his paintings and murals, and exhibiting those works in New York and elsewhere. By 1933, Curry had created works such as his iconic *Baptism in Kansas* (1928) and *Kansas Cornfield* (1933), as well as *Gospel Train* (1929), *The Old Folks (Mother and Father)* (1929), *Tornado* (1929), and *The Stockman* (1929). Like Wood, Curry and Benton had studied in Paris and the work of all three was informed by a deep appreciation of European art and art history. It was not until 1933, however, one year before Hollingsworth returned to Jackson, that the works of Wood, Benton, and Curry were exhibited together for the first time in a Kansas City exhibition organized by the Ferargil Galleries of New York and promoted as "regionalist" art. Prior to that they had not met collectively, nor had they discussed the concept of an art movement or shared artistic vision. Wood and Curry first met at Stone City in 1933, and Wood met Benton for the first time in New York in 1934.

Until the end of 1934, in other words, when *Time* magazine placed Benton on its cover and united these artists through popular media in its story on "U.S. Scene" painting, they were not active as a group or art "movement." This was unlike the Regionalist writers at Vanderbilt University, who authored *I'll Take My Stand*, then gathering national attention. Nor did they share a focus and mission like the Southern writers who gathered in New Orleans and published the *Double Dealer* during the 1920s, or those who gathered around Cleanth Brooks and Robert Penn Warren in Baton Rouge and published the *Southern Review* in the 1930s and early

1940s.[35] By the time he returned to Jackson in 1934, Hollingsworth was able to follow the evolution of the American Scene in painting as it evolved into what came to be called "Regionalism." This shift became evident across the nation and in numerous federal buildings and art programs. By 1934 and 1935 it was evident that the federal government was funding art that focused on the local and the regional, encouraging the type of work and subject matter Hollingsworth would explore in his native state from 1934 to 1944.

During his years in Chicago, Hollingsworth enjoyed regular access to the art and galleries of the Art Institute of Chicago, and was offered the opportunity to study the evolution of the 1933 Chicago World's Fair, the "Century of Progress" Fair, which was designed to embody the futuristic aspirations of America during the Depression. Hollingsworth's exposure to the collections, exhibitions, and programs at the Art Institute and the World's Fair from 1930 to 1934 undoubtedly informed his professional activities when he returned to Mississippi, including the exhibition programs he organized with Karl Wolfe at Jackson's Municipal Art Gallery as well as the art program he established at Millsaps College and advanced with Wolfe. Chicago historian Dominic Pacyga has concisely described the Chicago Fair's scope and attendance figures. "The Century of Progress Exposition opened on May 27, 1933, on 477 lakefront acres just south of the Loop. It closed on November 12, but reopened for a second year on May 26, 1934, and ran again until October 31… Because of its two-year run, fair attendance far surpassed the 1893 Columbian Exposition with 48,796,221 visitors." In contrast to the earlier fair, known as the "White City" due to its classical architecture and Beaux Arts planning, the "Century of Progress" Fair looked to the future, offering hope and relief from the nation's economic hardships. "Even as Chicagoans and guests from all over the world visited futuristic structures such as the Chrysler Building, the Sears, Roebuck and Company structure, and the House of Tomorrow and rode the Cyclone roller coaster or walked the streets of the Belgian Village, the Great Depression continued to wreak havoc on the city and the nation."[36]

The Fair offered notable artworks that may have inspired Hollingsworth's studies and evolving work. As a student at the

School of the Art Institute, he would have witnessed the Institute's ongoing efforts to organize one of the largest art exhibitions ever presented in America, one that would attract unprecedented crowds and foretell, in some ways, the "blockbuster" era of American art exhibitions. As Neil Harris recently affirmed, there was little question about the museum's stature then, noting that "the Art Institute in the 1920s boasted the largest membership of any American art museum, exceeding even the Metropolitan in New York; during some years of the 1920s it surpassed the Met's attendance as well. With its enormous art school, annual juried exhibitions, and a broad range of social and educational programs, the Art Institute laid claim to being the most significant cultural institution in the Midwest and one of the most important in the nation."[37] As part of its efforts to present art with the 1933 World's Fair, the Art Institute organized three major exhibitions—with almost 800 paintings, 200 watercolors, pastels, and drawings, and 133 sculptures—with one devoted to art from the thirteenth to nineteenth centuries, another devoted to French and American paintings of the past one hundred years, and a third devoted to American and contemporary art, featuring more than one hundred and fifty American artists, all installed in the galleries of the Art Institute. The *Chicago Tribune* heralded this as a "landmark in American cultural history."[38]

Hollingsworth, who witnessed this activity during the Great Depression after coming from a city without a public art museum, could not have failed to be impressed by the exhibitions and the public response to art, evidenced by the daily crowds there. The museum recorded over 700,000 paying guests for the exhibition (there was a twenty-five cent admission fee) and over 1.5 million additional guests who visited the rest of the museum for free, for a combined total of over two million guests in a five-month period in 1933, an extraordinary number then. Looking through the Fair's 1933 exhibition catalogue, easily available to Hollingsworth, he would have found prominent reproductions of Curry's *Baptism in Kansas* and Wood's *American Gothic*, along with reference to Benton's *Cotton Pickers*, all in a catalogue featuring reproductions of masterpieces by Botticelli, Titian, Tintoretto, Tiepolo, El Greco, Velazquez, Goya, Rembrandt, Rubens, Vermeer, Ingres, Corot,

Degas, Monet, Manet, Renoir, Cézanne, Van Gogh, Matisse, Picasso, Kandinsky, Duchamp, Whistler, Eakins, Cassatt, Ryder, Hopper, and others.[39] When the Fair continued for a second season in 1934, the Art Institute placed more emphasis on American art, including, as Harris indicated, "an entire room of Whistlers, along with famous paintings by Thomas Eakins, John Singer Sargeant, Albert Pinkham Ryder, Mary Cassatt, George Bellows, and others."[40] Hollingsworth, accordingly, had the opportunity to see one of the largest exhibitions of American art assembled prior to the American Bicentennial projects of 1976.

Another artistic highlight of the Fair and one of its most publicized pavilions, was that of Indiana, which showcased Thomas Hart Benton's "State of Indiana" mural series. By December 1932, when Benton was commissioned to paint the Indiana murals, he was becoming nationally known for his paintings, teaching, and lectures, especially for his murals at the New School for Social Research in New York, *America Today* (1930), and those at the Whitney Museum of American Art, *The Arts of Life in America* (1932). Both murals incorporated images from his travels and studies of the South. One month after the unveiling of his Whitney murals, Benton was commissioned by Indiana to paint one of the largest, most ambitious murals in American art history, in one of the shortest allocated time periods for such a major project. Measuring twelve feet high, and 232 feet in length, the murals would fill a Fair pavilion that was still being designed in December 1932. With an opening date of May 1933, Benton had less than six months to research, plan, and complete the murals. In January of 1933, Benton began a period of intensive travel in Indiana, marked by exhaustive research into the history and people of the state, and followed by months of planning and painting. He completed 2,600 square feet of tempera murals for the *The Social History of Indiana*, depicting the state's evolution from the early Native American potters to the Depression and New Deal era.[41]

The Indiana murals were accompanied by a guidebook, *Indiana: A Hoosier History* by David Laurence Chambers, which Hollingsworth could have purchased, featuring Benton's essay on the project, "A Dream Fulfilled." In that essay, Benton stated that he wanted to create art forms that would produce "a grip on the life

Soda Fountain
1933
lithograph
9 x 6.75 in.
1987.006

Over the Black Hawk
1933
lithograph
10.25 x 15.25 in.
1987.005

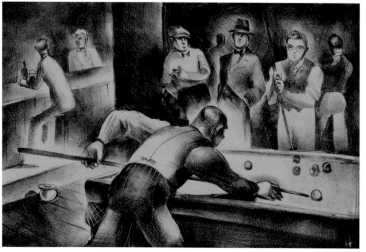

of men and an art that would have meaning for men. I saw that for all the talk on the subject there could be no American Art unless its form was generated in the midst of the meanings and values that were American."[42] In Benton's murals and his call for "American Art," in the emphasis on American art in the Art Institute's World's Fair exhibitions, in the acquisition of Wood's *American Gothic* by the Art Institute, and in many other ways, there can be little question that while in Chicago William Hollingsworth was introduced to the exhibitions and initiatives that reflected the latest directions in American art. Perhaps in response to these influences Hollingsworth produced a series of lithographs in 1933, incorporating subjects that reflected the larger Depression-era American art world.

The range of his print subjects was diverse, reflecting the interest in printmaking evident in the 1930s American art world, including the growth of printmaking workshops at art schools, colleges, universities, community schools, and local art associations. Prints were populist and affordable art forms, available to the masses and to Depression-era art collectors who could no longer afford paintings. By 1934, for example, the Associated American Artists Company in New York sold prints by major American artists for $5 and $25. One print by Hollingsworth, *Windy City*, reflects his response to the city's notorious winds blowing through a crowded Chicago street. Another, *Grocery*, reflects the type of genre scene popular with realist painters and printmakers, while *Dance Team* shows the type of dancers common in the city's clubs and dance floors. *Soda Fountain* reflects scenes associated with movies and fan magazines of the era, depicting a fashionably dressed young woman, seated, expectantly waiting at the counter—an urban creature, attuned to her times and opportunities.

Over the Black Hawk depicts a poolroom scene, recalling the works of Ash Can School artists such as George Bellows (1882–1925), and again reflecting continuing interests in scenes of urban realism and daily life. *Bootleg* shows a well-known side of Chicago, associated with Al Capone, gangsters, and organized crime of the city, in both reality and in myth. It is also similar to a scene painted by Thomas Hart Benton in 1927, *Bootleggers*, which was later incorporated as a larger image in his *America Today* mural of 1930. Hollingsworth's

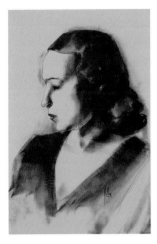 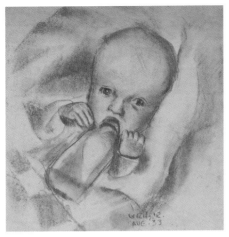

Jane
1933
lithograph
16.5 x 9.5 in.
1987.188

no title
August 1933
Conté crayon on paper
7.75 x 8 in.
1987.276

Billy
August 1934
oil on board
10 x 8 in.
1987.176

Hollingsworth and Billy, with first oil portrait of Billy, March 1935.

Pick-Up shows young women on the street conversing with sailors in uniform, not unlike the scenes associated with Reginald Marsh (1898–1954), Paul Cadmus (1904–1999), and other national painters of the era (see p. 13). In contrast, a scene such as *Holy Family* reflects traditional religious iconography in the lithographic medium, and may also reflect Hollingsworth's anticipation of the upcoming birth of his son and the establishment of his own small family unit which became central to his life and art that year. Other prints by Hollingsworth in this era included *Hold-Up*, *Big Business*, *Old Beer Drinker*, *Hail King of the Jews*, *A Tale of Woe*, and *Christ Dreams*. While these prints reflect this period and his experiences in Chicago, there seem to be few extant paintings from this period.

In Chicago Hollingsworth met Celia Jane Oakley (1912–1986) from Moline, Illinois, and a student at the Institute's School of Fashion Illustration and Design. They were married in 1932 and continued their studies at the Art Institute. In 1933, the year he produced the lithographs, he sketched and painted images of her, and created a print devoted to this subject. In the same year they also became the parents of a son, William Robert Hollingsworth III. Hollingsworth began a long-term portrait series devoted to his son soon after birth. The series of portraits and studies devoted to his son was notable for its focus and sophistication, as well as its insights into the artist, his parental love, and protective vision of an only child, as shown in *Sketch of Bill, 3/13/34* and a few months later, in *Billy*, from August 1934. Hollingsworth, Jane, and Bill formed a tight family environment which served as a protective enclave in Chicago. It would continue to do so when they returned to Jackson in 1934.

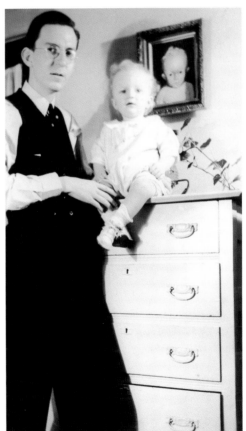

Jackson

1934 to 1944

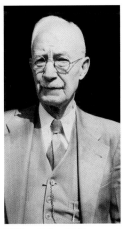

William and Jane Hollingsworth planned to remain in Chicago following graduation from the Art Institute and they hoped he might find employment in a commercial art gallery or similar art space. Yet, despite the excitement and crowds associated with the World's Fair, the lingering impact of the Great Depression and the lack of employment opportunities ended those hopes. Accordingly, they decided to return to Jackson in 1934, and ultimately moved into the family home on President Street,

William Robert Hollingsworth, Sr., early 1940s.
The Hollingsworth family: William, Jane, Billy, and Boy, circa 1940.

where his father still lived. Living there, Hollingsworth created a new extended family, including his wife, his son, and their terrier, "Boy." They lived in the heart of downtown Jackson, the state's largest city, yet it was quite a change from the larger, more sophisticated environment of Chicago with its rich artistic and cultural life, and the many opportunities offered them at the Art Institute. They now lived in a city without an art museum and set to work with a small but talented group of artists and writers to advance Jackson's cultural stature.

By the time the Hollingsworths moved to Mississippi, William Faulkner had established a national reputation as a writer with works that focused on the history and people of Mississippi. By 1934 his published books included *Sartoris* (1929), *The Sound and the Fury* (1929), *As I Lay Dying* (1930), *Sanctuary* (1931), and *Light in August* (1932). For decades after their publication, Faulkner's writings served as inspiration to many Southern artists, offering the example of an artist who gained national and international recognition living in, and writing about, his native region. In addition to Faulkner's notable presence in Oxford, Hollingsworth discovered an evolving art scene in Jackson, including figures who had returned there, like them, to ride out the Depression in a familiar environment. This included Eudora Welty, Karl Wolfe (1904–1984), and Helen Jay Lotterhos (1905–1981). The Hollingsworths, Wolfe, and Lotterhos all attended the School of the Chicago Art Institute and found common ground in that shared training and urban experience. Hollingsworth

and Wolfe quickly connected and began sketching together in the field, often along Old Canton Road. Hollingsworth also became friends with a Jackson neighbor, Lee Downing.

By the end of 1934, as Hollingsworth settled into Jackson and became acquainted with the artists who were working there, the American Scene movement evolved into what the popular press called the "regionalist" movement. In December 1934, Thomas Hart Benton was identified as its leader when his self-portrait appeared on the cover of *Time* magazine. Benton was also the first artist to be featured on *Time*'s cover. It can be argued that the power of the popular art media, paralleling that of the film and music worlds, emerged during this era, building upon developments in the 1920s, including the growth and popularity of radio, magazines, films, dance, and musical recordings. During the 1930s, *Time*, *Life*, and other popular magazines played vital roles in bringing art and culture to America's mass audiences. The art featured as "American" art was embodied in figures like Curry, Wood, Benton, Charles Burchfield (1893–1967), Reginald Marsh, and others. The December 1934 issue of *Time* was influential in this period because of its focus on American art and artists. *Life* magazine followed suit during the later Depression and war years.[43]

Jackson did not have an art museum when the Hollingsworths arrived. The nearest and oldest Mississippi art museum was the Lauren Rogers Museum in Laurel which opened a library in 1923 and an art museum wing in 1924. There were older art museums and art institutions in nearby states in 1934, including the Brooks Memorial Art Gallery in Memphis (opened in 1916) and the Isaac Delgado Museum in New Orleans (opened in 1911). In Mississippi and other Southern states during the Great Depression, increasing levels of professionalism appeared in the programs of state and regional art associations, art organizations, and summer art camps and colonies. The Mississippi Art Association became an increasingly

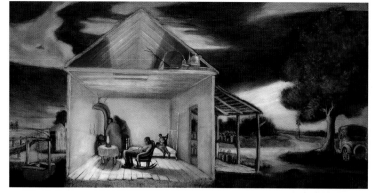

John McCrady
Evening Meal, Duck Hill, Mississippi
1934
oil on canvas
21.75 x 42 in.
Collection of Ogden Museum of Southern Art,
New Orleans, Louisiana
Gift of the Roger H. Ogden Collection

important force in the 1930s, as did the Municipal Art Gallery in Jackson, especially after Hollingsworth and Wolfe became active there.[44] New Orleans was recognized for its art world and for organizations such as the Arts and Crafts Club, including its New Orleans Art School, which attracted Mississippi native John McCrady before he studied with Thomas Hart Benton in New York, at the Art Students League. In 1934, McCrady returned to New Orleans and painted a range of regional images including subjects based on his native state such as *Evening Meal, Duck Hill, Mississippi* (1934).

The Southern States Art League, led by Ellsworth Woodward (1861–1939), was an influential organization in these years and produced a wide range of traveling Southern exhibitions. Hollingsworth became increasingly involved with these exhibition programs, and his art was featured and received awards in a number of them. After returning to Jackson, Hollingsworth became active exhibiting his art in Mississippi and soon received recognition for those works, including a portrait prize at the Mississippi State Fair in 1934. He later received a silver ribbon from the Mississippi Art Association for his oil painting, *Vagabond's Respite*. The following year an oil painting, *Black and White* (see p. 16), was included in an exhibition at the Cincinnati Art Museum and that work was included in an All-American Show at the Art Institute of Chicago, an honor which held special meaning for him. In 1935, his oil painting, *Tired, Oh, Lord, Tired* (see p. 15), was awarded the gold medal from the Mississippi Art Association and that work was selected for inclusion in an exhibition at the Cincinnati Art Museum in 1936.

Beginning in 1934, Hollingsworth was employed by the Federal Emergency Relief Administration (FERA) where he worked in a range of clerical duties. For Hollingsworth, the ability to work as an artist while supporting his family was of paramount importance

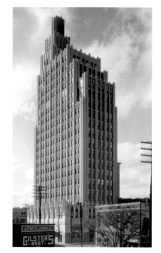

Tower Building, Jackson, 1930s.
Photo © Gil Ford Photography.

during the Depression. The emergence of federal relief programs proved to be vital to many seeking work in these years. Federal art programs served as an important source of support and encouragement for artists. Unfortunately Hollingsworth was not involved in those programs. He was offered a more mundane form of employment, but it allowed him to support his family and gave him time to paint on evenings and weekends. At this time, Eudora Welty was hired to be a marketing and information specialist for the Works Progress Administration (WPA). Welty began to use her camera to document the impact of the Depression on her trips across Mississippi, creating images that were often similar to those witnessed by Hollingsworth on his sketching trips. Both Welty and Hollingsworth were based in offices located in the Tower Building and saw each other regularly there. In Chicago, Richard Wright was employed by the WPA Federal Writers Project in 1935 to complete research for its American Guide series and he later worked with the WPA Federal Theater Project in 1936, before moving to Harlem in 1937.[45]

Soon after Hollingsworth began working for FERA, he sketched his office environment there (see p. 14). The FERA offices were located downtown in the Tower Building, one of the city's newest and tallest buildings, a structure that may have reminded him of the office towers he knew in Chicago. Every morning, Hollingsworth left the confines of his family's historic home downtown, walked along Jackson's sidewalks with other office and government workers in the state's capital city, entered the Tower Building, where he took an elevator to his floor and began his predictable routine. In one of his more significant works, *Elevator, Tower Building*, Hollingsworth (a sophisticated artist who knew Chicago's urban architecture and its patterns of life) painted a contemporary urban environment, one he encountered every day at work. It was inspired by his observations and experiences in Jackson and influenced by his years in Chicago, yet it was not unlike images painted by Reginald Marsh, Edward Hopper (1882–1967), Thomas Hart Benton, and other urban realists active in New York and Chicago. Contemporary life, Hollingsworth indicated, was not all that different in Jackson than in other major cities of the Depression era.

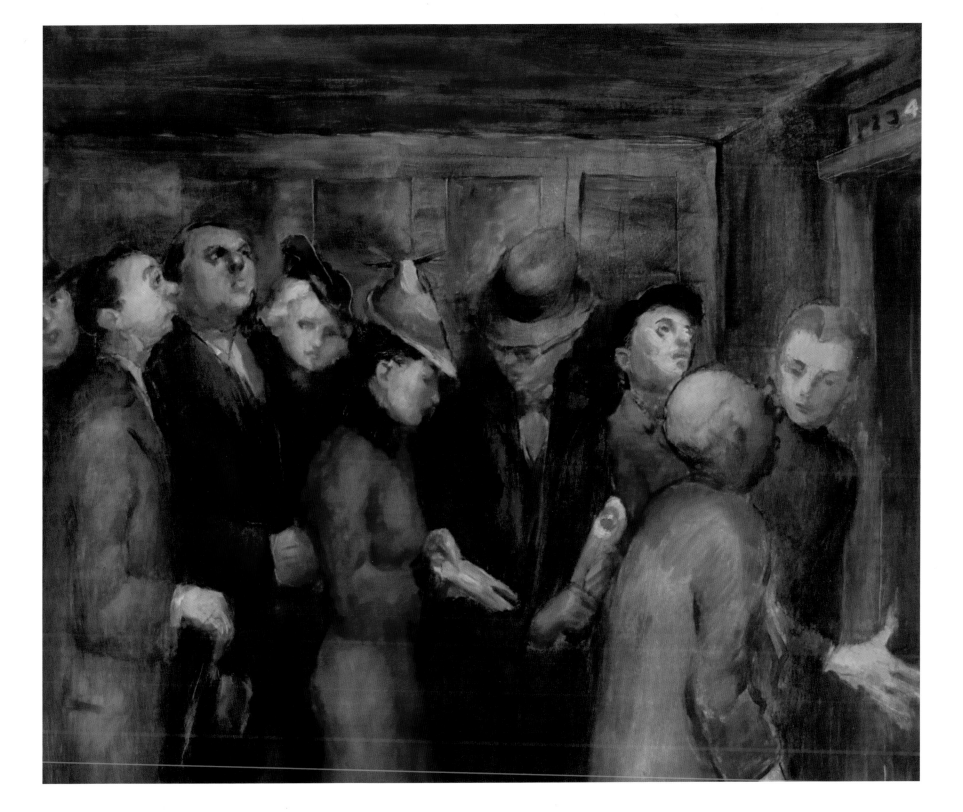

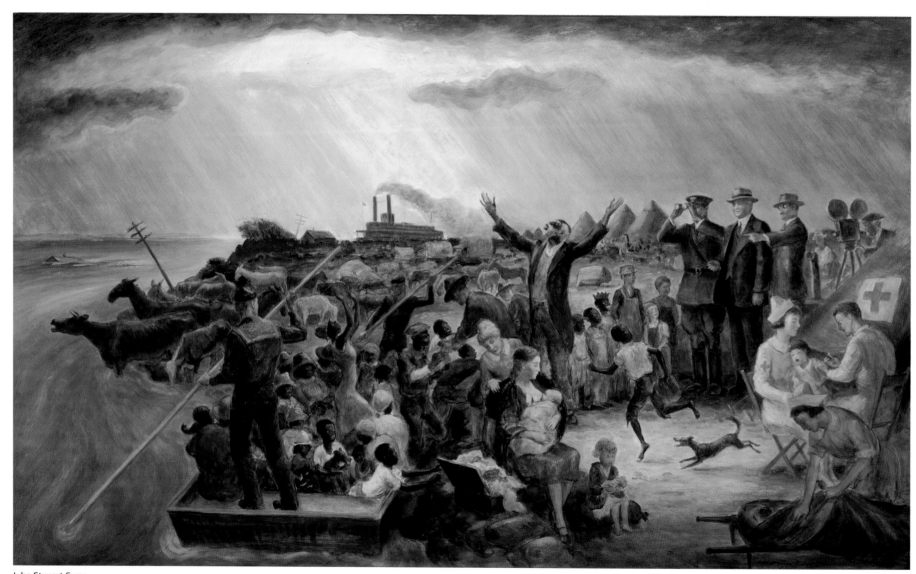

John Steuart Curry
Hoover and the Flood
1940
oil on panel
37 1/2 x 63 in.
Collection of Morris Museum of Art, Augusta, Georgia
1996.009

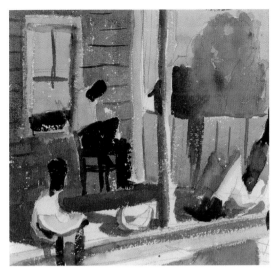

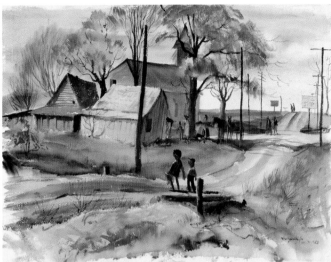

His weekday routine focused on his position with FERA and he painted in the evenings and on weekends. At the Jackson Municipal Art Gallery show in 1936, he sold his first watercolors, an encouraging sign, as well as the beginning of his move toward financial independence through art sales. The next year his watercolor, *Siesta*, was awarded the William Tuthill Prize ($100) at the International Watercolor Exhibition at the Chicago Art Institute. As O. C. McDavid indicated in his study of Hollingsworth's career, these were the first in a series of positive developments for the artist at that time. "That led to a one-man exhibition of thirty-five paintings at the Chicago Galleries and the beginning of a series of exhibitions showing his paintings—at Baltimore, Memphis, New Orleans, San Diego, Oakland and Pomona in California, the University of Notre Dame, and at galleries and colleges throughout his native Mississippi."[46]

In 1936, as Hollingsworth's works were being exhibited in Jackson, Cincinnati, and Chicago, events surrounding two leading American artists may have reinforced Hollingsworth's decision to return to Mississippi. Media coverage indicated that all three of the designated leaders of the "regionalist" movement were now located in the nation's heartland. In 1935, not long after his appearance on the cover of *Time*, Thomas Hart Benton announced that he would leave New York and his position at the Art Students League to move to Kansas City in his native state of Missouri. Benton accepted a teaching position at the Kansas City Art Institute where he taught until 1941, as well as a prestigious commission to paint a new mural for the Missouri State Capitol titled *A Social History of Missouri*. This project was similar to his *Social History of Indiana* in that it offered him an opportunity to research, explore, and paint the history of the state, however in this case it was his *own* state, where his father and other relatives contributed to that history.

In September 1936, John Steuart Curry left Connecticut for Wisconsin. The *New York Times* announced, "Curry Is Named 'Artist in Residence'; Wisconsin Acts to Aid Rural Culture." He had become the nation's first artist-in-residence, at the University of Wisconsin. In November 1936, *Life* magazine devoted a major article to Curry and his art. In November 1937, Curry's designs for new murals at the capitol in Topeka were approved by the Kansas Murals Commission, with panels including the *Tragic Prelude*, *The Plagues*, *Corn*, *Wheat*, and *Kansas Pastoral*. Curry worked on these murals for five years, from 1937 to 1942, enduring criticism by state legislators and others, but persisted to produce one of the nation's most significant capitol mural projects.[47] During this time, he was commissioned by *Life* magazine to produce a painting devoted to a Southern subject, titled *Hoover and the Flood*, and dedicated to the 1927 Mississippi River Flood. *Life* reproduced it as the centerpiece of a May 6, 1940, article, stating, "John Curry is famous not because he always paints the American Scene but because he always paints it well."[48]

As Hollingsworth and his Jackson art colleagues observed, media coverage about Benton and Curry indicated the significance of their return to the heartland, which embraced them, and their

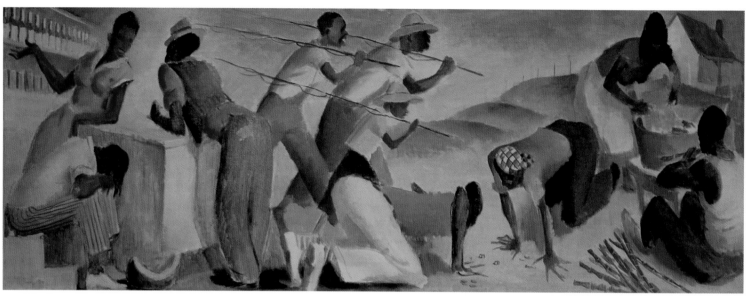

Design for WPA post office mural
1939
oil on canvas
mounted to cardboard
13.5 x 36 in.
Collection of the Museum Division, Mississippi
Department of Archives and History, Jackson
1963.17.1

rejection of New York's "elite" art world. It was, some suggested, a new era in American art, a time when artists should return to the places they knew best, where they were most qualified to represent the interests of the local people. For William Hollingsworth, Karl Wolfe, and Helen Lotterhos this was an historic moment, when their evolving interest in the history, people, and environments of Mississippi seemed to align with larger trends in the American art world. In reality, they were ahead of those trends because they returned to Mississippi before Benton and Curry departed from the East Coast. These activities in the art world mirrored developments in Southern literature during the 1920s and 1930s, as evident in the lives and work of William Faulkner and Eudora Welty in Mississippi.

By 1936, federal art programs were exerting a significant influence upon Mississippi's art world, impacting a diverse range of regions and communities. Funding from the Community Art Center program of the Federal Art Project supported the Delta Art Center in Greenville, and the city of Oxford received federal funding in 1936 to build the Mary Buie Museum, which later housed the Oxford Federal Art Gallery (1939–1941). Using funds from a WPA

individual artist grant, the city of Oxford acquired John McCrady's painting, *Oxford on the Hill*, and in Ocean Springs, Walter, Peter, and Mac Anderson were commissioned with federal funds to create murals and ceramic tiles for the Ocean Springs High School. Walter Anderson submitted five different design proposals for a post office mural in the James O. Eastland Federal Building in Jackson, yet all were rejected in Washington. Instead, the artist Simka Simkhovitch (1893–1949) from Connecticut was selected to paint the mural, *Pursuits of Life in Mississippi*. As Patti Carr Black has noted, this mural "would become the center of a minor controversy during the civil rights movement. Criticized for depicting slavery in a romantic manner (it is actually a 1930s scene), it was concealed by draperies during the volatile days of the 1960s."[49] Walter Anderson (1903–1965) was not awarded the Jackson mural project, but he did receive the commission for a notable historic mural in Oceans Springs.

One of the most important federal programs in Mississippi and the South during these years was operated by the Treasury Department Section of Painting and Sculpture, later known as The Section of Fine Arts, which created a wide range of post office mural

projects across the state. These projects included: John McCrady's *Amory in 1889* in Amory (1939), Louis Raynaud's *Life on the Coast* in Bay Saint Louis (1938), Stefan Hircsch's *Scenic and Historic Booneville* in Booneville (1943), Julien Binford's *Forest Loggers* in Forest (1941), Simkhovitch's *Pursuits of Life in Mississippi* in Jackson (1938), Stuart R. Purser's *Ginnin' Cotton* in Leland (1940), Karl Wolfe's *Crossroads* in Louisville (1938), Lorin Thompson's *Legend of the Singing River* in Pascagoula (1939), Donald H. Robertson's *Lumber Region of Mississippi* in Picayune (1940), and Beulah Bettersworth's *White Gold in the Delta* in Indianola (1939).[50]

Working within the context of these mural projects, Hollingsworth created a design concept for a mural in his native state, perhaps inspired by the success of Karl Wolfe, who was awarded a mural commission for the post office in Louisville, Mississippi. The two artists were close in these years, and it may have seemed appropriate for Hollingsworth to compete for a mural project, just like Wolfe. Francis V. O'Connor has described Hollingsworth's submittal as a "study for a post office mural on the theme of the 'southern negro.' It displayed a strong design and followed Rivera's and Benton's montage style, which allowed the simultaneous depiction of events in contiguous spaces." In this proposal, O'Connor noted, "one sees to the left a couple flirting while a boy regrets a surfeit of watermelon. In the middle, three generations are energetically off 'goin' fishin',' while the stay-at-homes play craps. To the right a woman washes clothes while a man sorts a pile of sugar cane, perhaps seeking the perfect reed from which to make a flute. All three events are integrated into a fluidly coherent yet carefully compartmentalized space."[51]

In addition to these loftier and more complex mural ambitions, Hollingsworth regularly practiced his basic working routine, one reflected in his major themes and issues, and which also shows the nature of his highly focused personality. Hunter Cole has described his methodology for working in and around Jackson (developed earlier in Chicago), noting that, operating out of his downtown studio on President Street, "one can sense this close-to-home spirit and his perceiving, penetrating gaze on an intimately known terrain. He sketched sometimes while in the parked car. When in public, he concealed his hand and paper so that he might remain unobserved

as he captured the spontaneous gestures of the idlers along Farish Street and Mill Street." As Cole noted, he also remained an unobtrusive presence on the streets. "Like Welty, Hollingsworth was a self-effacing, shy observer, a shadow outside the scene. To those he sketched with such ardor, Hollingsworth was a loner hardly worth noticing. He was five feet ten. He had deep-brown hair and brown eyes, weighed 135 pounds, and wore spectacles that had gold wire frames. His draft card said that he had a small scar on his chin."[52]

William Robert Hollingsworth, Jr., 1940.

His sketching and exploratory trips around Jackson, often accompanied by Karl Wolfe, were central to the evolution of Hollingsworth's art in these years, as was his growing friendship with Wolfe. They were acknowledged as the primary male artists working in Jackson's female-dominated art world. As Wolfe recorded in his autobiography, theirs was a significant professional and personal relationship. "When William Hollingsworth came home from art school with a wife and child, and yearning to go somewhere else, with no funds beyond pay from a WPA job, I was glad to have another male to talk to. When I convinced him that there was something worth painting right outside any window in his father's house, where he lived, he painted from every window in watercolor, with a style immediately personal." As Wolfe noted, after Hollingsworth accepted his advice and embraced the unique subjects that awaited him "outside any window" in his native state, they became increasingly active in their explorations and projects. "Onto the sidewalk, the city streets then in to the country, he painted, with more and more depth, a poetry as masculine as Whitman's. We took over the gallery and tried to make it interesting to all tastes; the results were not encouraging."[53]

Karl Wolfe with Hollingsworth, Oxford, Mississippi, April 1942.
Courtesy of Mississippi Department of Archives and History, Jackson.

As Wolfe indicated, during the 1930s he and Hollingsworth became the major advocates for advancing operations at the Municipal Art Gallery in Jackson, and also maintained the programs of the Mississippi Art Association. In doing so, they built a strong foundation for the growth of arts institutions and museums in

Sudden Shower
September 4, 1937
watercolor on paper
14 x 19 in. (sight)
Purchase
1937.003

the city and state, including Hollingsworth's founding of the Art Department at Millsaps College, where Wolfe became an active partner, and in establishing a foundation for opening the Mississippi Museum of Art in 1978. No doubt their experience in Chicago's art world, as well as their understanding of the importance of a major art museum such as the Art Institute of Chicago—with its diverse exhibitions, collections, and educational outreach programs—informed their activities in Jackson and across the state. Away from these urban art duties and civic responsibilities, they enjoyed both the privacy and the nature of the discoveries they made in Mississippi's richly layered natural environment on their sketching trips in the countryside. For Hollingsworth, as Wolfe suggests, these were serious, even emotionally engaging events, and perhaps even spiritual events. "He seemed, unlike me, very calm and methodical while painting. So once while we were out in the field together I asked him if he was not excited by his subject matter. He replies, 'Excited? I am so excited that I think my insides are going to shake out.' Then I noted how his bottom lip was trembling."[54]

One of the most important subjects discovered by Hollingsworth after his embrace of Mississippi was its African American culture. Hunter Cole has emphasized the significance of this development. "When Hollingsworth and his northern wife came back to Mississippi as the Great Depression of the 1930s struck the nation, he rediscovered the culture of Southern black people. To the west of the city of Jackson and separate from the mainstream, was the district of black neighborhoods and social life. Except as servants and laborers, black people were strictly segregated and kept apart from white society by social and political codes. This black culture theme developed into one of the mainstays of Hollingsworth's art."[55] An example of this is the work titled *Sudden Shower* (1937), a watercolor painting featuring an African American man running, arms and legs outstretched and filling much of the composition, followed by a young boy and a girl holding a newspaper over her head, splashing water as they run, dodging rain drops. It is a masterful watercolor painting, using the medium in an accomplished manner, in a work that appears to be as spontaneous as the event it captures. However, based upon many sketches and studies, it is instead a carefully composed piece that the

artist developed to *appear* spontaneous, to convey the immediacy of the moment and the rush of figures caught in a Southern downpour.

Images of African Americans were a major focus in his paintings of these years, as they were in the Mississippi photographs of Eudora Welty, reflecting the profile of the state's significant African American population. In recent years, some critics have questioned Hollingsworth's depiction of his African American subjects, often reflecting perspectives common in the twenty-first century American art world. Other artists active in the 1930s, including Benton, Curry, McCrady, and Simkhovitch (as noted earlier) have been criticized along similar lines. Hollingsworth and Welty, along with other artists who focused on black subjects during the Jim Crow era, worked in a very different social and artistic environment than the one we know today, especially in Deep South states like Mississippi. This is evident even in a federally sponsored project of 1938, *Mississippi: The WPA Guide to the Magnolia State*, which reflects the racial attitudes and stereotypes of that period. The opening lines of the *Guide* chapter titled "Negro Folkways" demonstrate the attitudes of the time:

Different from Louisiana folk Negro in speech and from the east coast Negro in heritage, the Mississippi folk Negro stands alone, a prismatic personality. Those who know him well enough to understand something of his psychology, his character, and his needs, and like him well enough to accept his deficiencies, find him to be wise but credulous—a superstitious paradox. He seems to see all things, hear all things, believe all things....The Mississippi folk Negro today is a genial mass of remarkable qualities. He seems carefree and shrewd and does not bother himself with the problems the white man has to solve. The tariff and currency issues do not interest him in the least...As for the so-called Negro Question—that, too, is just another problem he has left for the white man to cope with.[56]

In Hollingsworth's paintings, watercolors, and sketches, as in Welty's photographs, we see a considerably more nuanced perspective on the African American populations of Jackson and

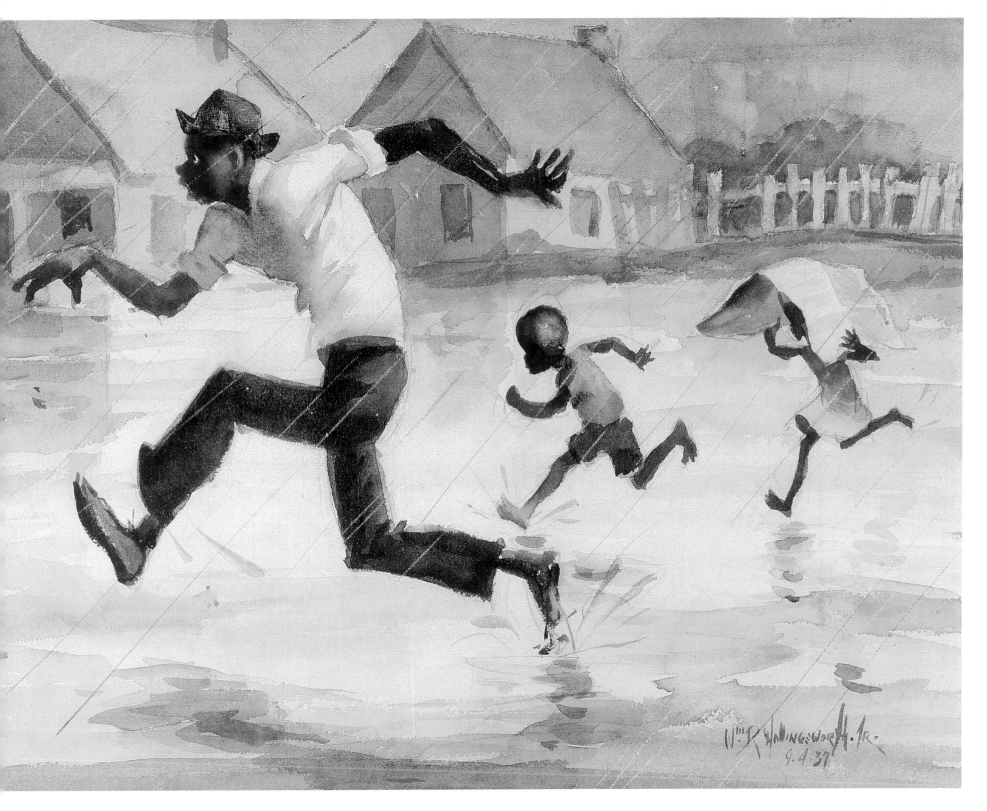

High Farish
1941
oil on canvas
24 x 30 in.
Collection of BancorpSouth, Jackson, Mississippi

the state of Mississippi (see, for example, Welty's photograph of a "Colored Only" entrance in Jackson). For both Hollingsworth and Welty, the experience of living in the urban North broadened their point of view and enhanced their appreciation of African American culture. Upon returning to Mississippi in the 1930s, both accepted the opportunity to explore what that culture meant to their state. They understood it directly and it nurtured their own lives and those of their families.

Consider, for example, Hollingsworth's paintings of the culture and street life of Farish Street and Welty's photographs of street life and the African American church culture she discovered there. Hollingsworth's 1941 painting, *High Farish*, embodies this exploration with its central focus on the Farish Street Baptist Church, surrounded by a drug store and other retail shops in the segregated business district, and especially by streets and sidewalks filled with colorfully dressed figures—some holding umbrellas, some standing, others walking, one atop a mule (or horse) and others by a parked automobile. In bright light, with hanging overhead clouds, the painting presents a lively urban environment, one that may be informed by the artist's experiences in Chicago, but which depicts a scene near the home where he was raised. In the distance, the tallest element in the composition is the Tower Building, where Hollingsworth and Welty had worked in federal offices, making it a personal reference as well. Welty's photographs of the "Pageant of Birds" at the Farish Street Baptist Church offered a microcosm of the larger scene depicted in *High Farish*, one no less unique or memorable, depicting the costumes and attitudes of the figures dressed as birds, posing outside their local church.

In 1939, after working for five years in the FERA office in the Tower Building, and continuing to create art on weekends and at night, Hollingsworth and his wife decided that he should pursue a full-time career in art. While he painted and attempted to form a new career, she would work to support the family, as Hunter Cole noted. "Jane's talent for design and fashion and her keen sense of style were assets for dress-making. She set up her tables and her sewing machine in a downstairs room in the tower and announced her new career of designing and making trousseaus, wedding dresses, evening gowns,

Eudora Welty
The Century Theater Colored Entrance, Jackson
prior to 1935
gelatin silver print
© 1935 & 1985 Eudora Welty, LLC

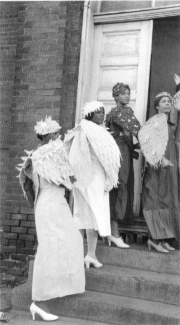

Eudora Welty
Untitled. Pageant of birds, Farish Street Baptist Church, Jackson
prior to 1935
gelatin silver print
© 1935 & 1985 Eudora Welty, LLC

Before the Sun
1939
watercolor on paper
17 x 22 in. (sight)
Gift of Mississippi Chemical Corporation
2005.017

and party frocks…Hollingsworth took a back room downstairs for his studio, although he preferred to work out of doors, directly in contact with the landscape and with the figures he sketched from life."[57] At twenty-nine years old, he was exhibiting and selling his art on a regular basis, and had won a significant number of regional and national awards. Though it was a risk for the artist and his family, his art was selling well and he had grown more confident in his art career as a viable way to support his family. This was no small accomplishment during the Depression years in Mississippi.

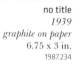

no title
1939
graphite on paper
6.75 x 3 in.
1987.234

The Critic
1937
graphite on paper
8.5 x 5.5 in.
1987.316

The production of his art, which had been more modestly paced during the years he worked with FERA, increased in 1939 and 1940 as he focused full-time on his art and career. During this period, he began to diversify his use of media, returning to prints and print-making, as well as wooden sculpture, woodcuts, and linoleum cut prints. In 1939 he began the last period of his career, one marked by a prolific output and his fiercely dedicated work ethic. He seemed to be at work constantly, and even in quiet times filled his sketchbooks with drawings and studies of his family, his art world friends, and the larger environment he discovered in Mississippi. He also demonstrated an equally committed focus to his arts administration, gallery, and curatorial activities.[58]

Hollingsworth's art continued to receive national and regional awards and recognition, as evidenced by the inclusion of his work in the 1939 World's Fair in New York, and recognition by the Chicago Arts Club, the Southern States Art League, the National Watercolor Society, and others. Being shown in the 1939 World's Fair may have brought back memories of the 1933 Century of Progress Exhibition in Chicago, when he was a student at the Art Institute. The New York World's Fair, with its focus on the future, "Building the World of Tomorrow with the Tools of Today," symbolized in its iconic Trylon and Perisphere, covered over 1,200 acres, cost over $150 million and featured exhibitions including "Futurama" and "Democracity." The arts were well represented across the grounds and in dedicated exhibitions including The Works Progress Administration Building, which included sculptures, paintings, murals, crafts, and other works sponsored by the WPA, and the Contemporary Art Building, described as the most comprehensive exhibition of works by living American artists ever assembled. Hollingsworth's inclusion in the exhibition in the IBM Building reflected the incorporation of art in many of the fair's pavilions, and suggested the significant role corporations and businesses would play as arts patrons in the years ahead.[59]

During this last period in his career, he continued to demonstrate a focused and highly methodical working manner, as O. C. McDavid has suggested. "The basis of his paintings was always the painstaking sketch. Many watercolors completed in the studio were begun on the scene—often from the seat of his automobile parked beside a country road or on a busy street, in good weather or bad. Weather, in fact, was a dominant element in many of his paintings—the sunshine, moonlight, rain—rain, rain, rain becoming a theme most frequently recurring in his sketchbooks and in his paintings." And, as McDavid emphasized, Hollingsworth worked and reworked his subjects. "A characteristic of the artist was his pursuit of an idea through many forms and phases, repeatedly portraying a particular theme or subject until he felt its possibilities were entirely exhausted…Favorite subjects were the wet city streets, rainy days anywhere and everywhere, goats…soldiers, scenes along Old Canton Road and at Stockett's Riding Academy, fishing and 'no-fishing' vignettes."[60]

Demonstrating his appreciation of atmospheric and environmental conditions, he completed a wide range of notable works around 1939 and 1940. One, titled *Before the Sun*, depicted a scene of the city awakening in early morning, with a railroad yard and industrial buildings in the foreground and Jackson's skyline in the background. A single worker walks across the rails, offering a sign of human life preparing for the day's work and maintenance

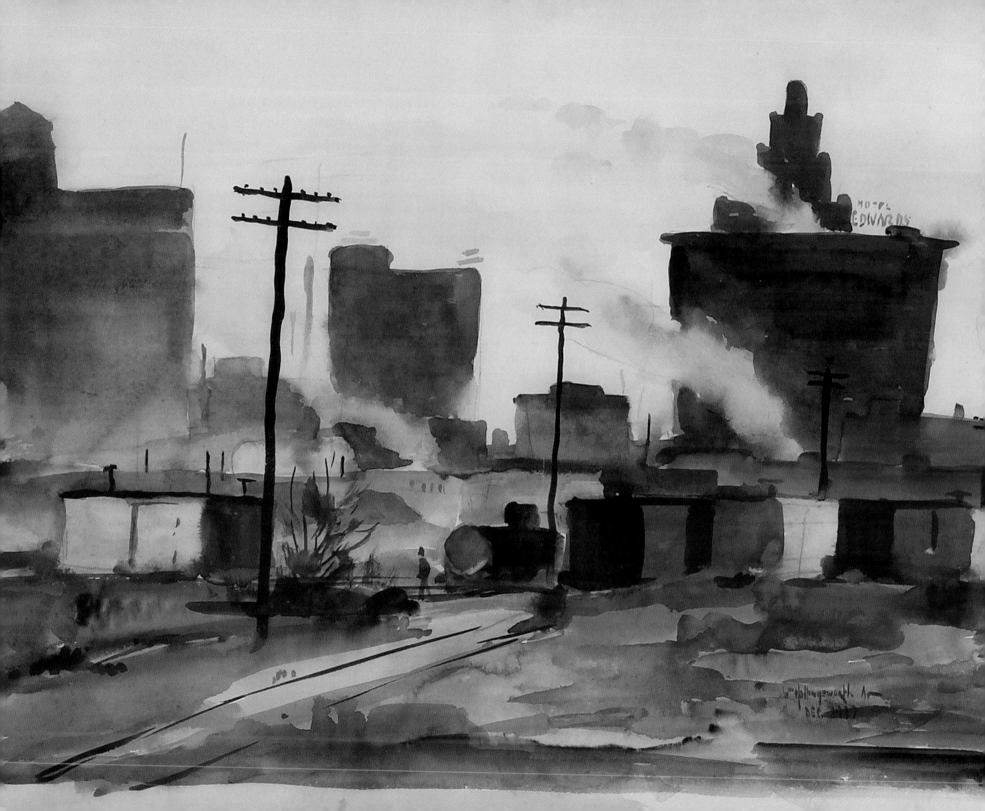

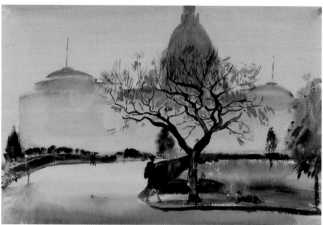

New Capitol, Jackson, 1940s.
Photo © Gil Ford Photography.

The New Capitol
November 1, 1943
watercolor on paper
15 x 22 in. (sight)
1987.067

Wet Hill
February 19, 1939
watercolor on paper
20 x 15 in.
Collection of Mary Alice and Donny White,
Jackson, Mississippi
Photo © Tom Joynt Photography

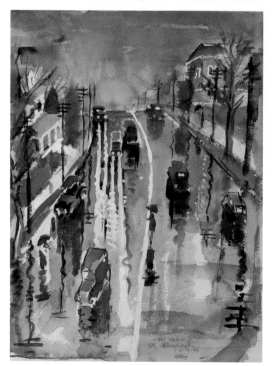

of the rail systems that served the city. In *The New Capitol*, he used the fluid quality of watercolor to suggest, as much as depict, the Mississippi State Capitol, located only a few blocks from his studio, a potent symbol of the state's political power, yet in this image one that existed more as an atmospheric and moody suggestion of a classical structure. *Wet Hill* (1939) depicted one of the rainy scenes he commonly painted. According to his widow it shows a Jackson scene on North State Street, near the old Baptist Hospital. Eudora Welty purchased it directly from the artist and hung the treasured piece in her living room. She later described its acquisition. "He framed it for me and told me that the paint was inferior. He said that it would fade, and it did. It wasn't his fault. In the Depression we couldn't afford better. The cost of the painting? Not much, maybe ten dollars."[61] She later purchased a second watercolor from him, *Low River*, painted along the Pearl River in 1942, depicting a scene that became a favorite subject for Wolfe and Hollingsworth on their expeditions into the countryside. The two men sometimes saw Welty painting with Helen Lotterhos in the same spot.

After leaving his job at FERA, Hollingsworth had more time to devote to his studio, and to promoting and exhibiting his work, often out of state. On November 15, 1940, for example he wrote in his journal that it was a day "of bitter cold—no painting done, but did get 22 wc's labeled, tagged and packed to take to Pineville, Louisiana, Sunday where they will be shown. And I to make a talk there on a show of Modern French." After delivering his talk in Pineville, he returned and sketched outside during the following weeks. On November 23, he recorded an image which inspired the concept for a painting he developed in 1941 (*The Countryman*). "When I saw the thing—just a flash, as we passed in the car, the countryman standing by his mailbox reading his newspaper in the autumn morning light in the year 1940 just hit me as saying something big. But not literally big—I do not mean that. Something big in an abstract way...painted well and free and easy, then it could easily be something profound." The next day, he wrote about his evolving concept for the painting. "This oil—more sky space though. Tawny—fall in color. Not too deep—depthy. Intense concentration on the figure. *Very* intense. Other areas sort of like *Pascin* would have

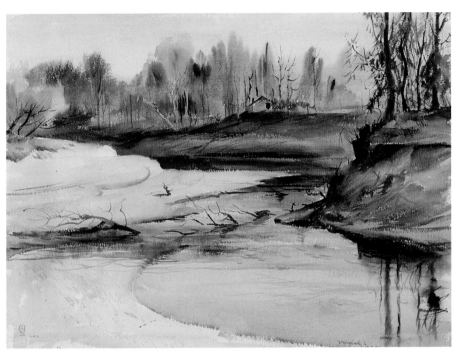

Low River
November 30, 1942
watercolor on paper
22 x 30 in.
1987.081

The Countryman
January 1-2, 1941
oil on canvas
18 x 22 in.
1987.015

done…Make it moody—intense sort of concentration. Not a man or a rural man reading his morning paper—all *America* reading his morning paper."[62]

Working in the studio on December 7, he experienced a sense of nostalgia for Chicago, as noted in his journal. "Finishing the third of the 'order' series…listening to Chicago radio—their repeated talk of snow and cold makes me homesick for Chicago with wind and snow and briskness and pep and good stuff and 'Els' and the City."[63] Later that month, on December 13, he traveled and spoke to a women's group in Holly Springs. "Home again after a pleasant and uneventful trip to Holly Springs. Made my talk satisfactorily—impressive I think." In addition to his own studio work and personal responsibilities, he remained occupied with the ongoing business of the Mississippi Art Association and the Municipal Art Gallery, where he planned, shipped, and installed many changing exhibitions. He was pleased, as he noted on December 15, 1940, to learn that one of his paintings would return to Jackson in a traveling national exhibition that had debuted at the 1939 World's Fair in New York. "And learning with pleasure that the 'IBM' collection of 53 American

paintings will come to Jackson late next year—the show my 'Drear' was bought for, same taking 7th prize."[64]

On New Year's Day in 1941, he wrote that he worried about the course of the war and its impact. "So the new year is begun. Here it was another day….over there—the bombs still fall, ships still go down, men fight, men die—and no-one is yet wise enough to stop it." He began the New Year working as well. "I did an 18x22 sketch today—in oil—of the notion that has already been alluded to—the country man reading newspaper theme…Jack's [Karl Wolfe] comments tonight on it were encouraging: Said my surface quality beautiful enough—that I have something of Picasso's design method. Never think of my work, myself, in relation to Picasso: always to Kuniyoshi—Marin—sometimes Matisse. So this comes as a stimulating compliment." He was, in fact, reading a new Picasso book published by Hyperion Press, so Picasso was much on his mind. Yet the artists who were cited the most by Hollingsworth as inspiration and as role models were Yasuo Kuniyoshi (1893–1953), John Marin (1870–1953), and Henri Matisse (1869–1954). Later that month, he traveled to New Orleans to see a significant Picasso exhibition presented at the Delgado Museum of

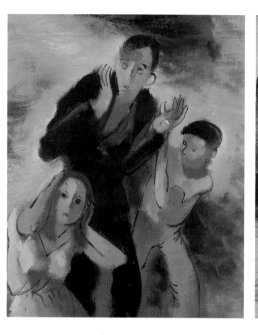
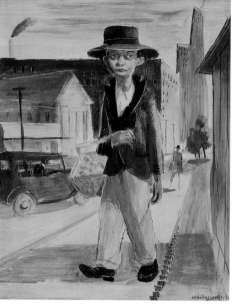

Fear
1941
oil on board
17 x 14 in.
1987.020

Peanut Boy
1941
tempera on board
20 x 16 in.
1987.021

Book Plate
1942
linocut
4 x 3 in.
1987.263

Art, including the painting *Guernica*, a masterpiece that provided ongoing inspiration to him. Two years later, in January 1943, he wrote, "am indebted to 'Guernica' to no end. What a painting *that* is! What a painter Picasso is!"[65]

The year 1941 was, in fact, a highly productive one for him, as evident in the number of major paintings produced. He completed a study version, then a final version of *The Countryman*. Then, inspired by *Guernica* and the cubist compositional style, he created a painting titled *Fear*, suggesting figures terrified by war, using his version of a cubist format in a work now in the collection of Millsaps College. He also painted a second version of *Fear*, in a very different style, which remained in his estate collection. He created one of his major paintings of the late years, *High Farish* (see p. 70), inspired by the street life of Jackson's Farish Street, and painted an unusual, seemingly surreal portrait, titled *Peanut Boy* (1941), depicting a strange young figure on a downtown street, with Jackson's Tower Building looming in the background.

A major advance for Hollingsworth, and for the arts community in Jackson, was the expansion of his teaching duties and the establishment of an art program by Hollingsworth at Millsaps College

in 1941. Before long he brought Karl Wolfe into the program and Wolfe eventually became a major figure in the evolution of the Millsaps art program. As Hollingsworth noted in his journal on December 21, 1941, he had been busy working on some watercolors, actively painting out of doors. "I also have an Art department at Millsaps College, three afternoons a week, taking only part of my time. And landscape class for private students continues."[66] He worked on a linoleum block print that month, returning to the medium he so successfully explored in Chicago with his earlier print series.

The bombing of Pearl Harbor, on December 7, 1941, and the subsequent expansion of World War II meant that many young men and women began serving in the military and home front effort. This impacted Hollingsworth and Wolfe as the war brought significant changes to Mississippi. While the war efforts increased, the Depression era relief programs were concluding, leaving many artists without their federally funded jobs. In 1942 those projects declined and fully ended in 1943. Hollingsworth started a new year, as he noted on January 1, 1942, working in the studio, "putting some last touches on a portrait, finishing a frame, hanging some new water colors and designing a book plate for us—which I spent

tonight cutting out of a linoleum block. It bespeaks 'Ex Libris—Jane and Hollie' and the design is built on Billy and Boy." He also painted along the Natchez Trace with Karl Wolfe, noting on January 3, "The Trace is beautiful! Beautifully planned roadway, and today with blue mist over the golden brush of fields—'twas something to tackle." He soon longed to work again outside: "I am going painting tomorrow—the war, the future…all fade and die when one is in the fields in joy with paint and brush. Escape? Hell yes, and a damned good one." Later that week he described his teaching: "This afternoon teaching at Millsaps and left class with a fine sense that I have succeeded in bestirring those boys and girls since the semester began." Due to the war, however, he worried about being able to recruit enough male students. On January 24, he noted that "Millsaps starts second semester Monday. I think I will lose two students—both boys; am hoping against hope that there will be no more, and with fortune, perhaps one or two new ones. Believe I can now round out my department next year."[67]

Eve
1942
hickory (wood)
10.5 x 2.25 x 2.25 in.
1987.070

Frame designs
from the artist's sketchbook
1942
graphite on paper
Courtesy of Mississippi Department of Archives and History, Jackson

Brown and Wet
1942
oil on canvas
26 x 32 in.
Collection of the Museum Division, Mississippi Department of Archives and History, Jackson
1985.63.1

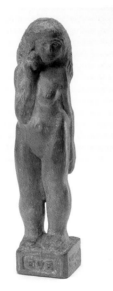

In February, his father gave Hollingsworth a new carving and drilling tool as a birthday present. On February 17, 1942, his thirty-second birthday, he wrote that he was working on a new wood carving. "Have worked the past two days carving a small figure—nude—out of a block of hickory…Am to call her 'Eve'—she holds an apple—and she wonders if she *should* propogate a world and race of men to grow up in 1918 and 1942 to kill and maim and destroy each other." Four days later he wrote, "Carving, carving, carving. The figure of 'Lady Eve' turned out swell. Hickory. And another frame." After learning in February that his two entries in the Virginia Museum biennial had been rejected, he was pleased to learn in April that "my 'Brown and Wet' (kids on mule) had been awarded the Benjamen Prize at the Southern States Art League

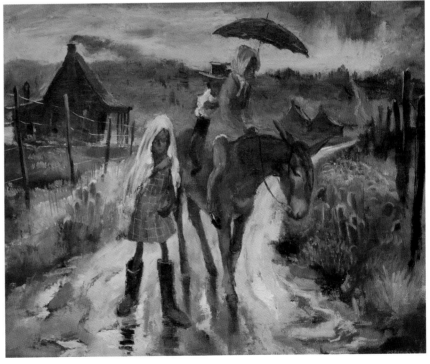

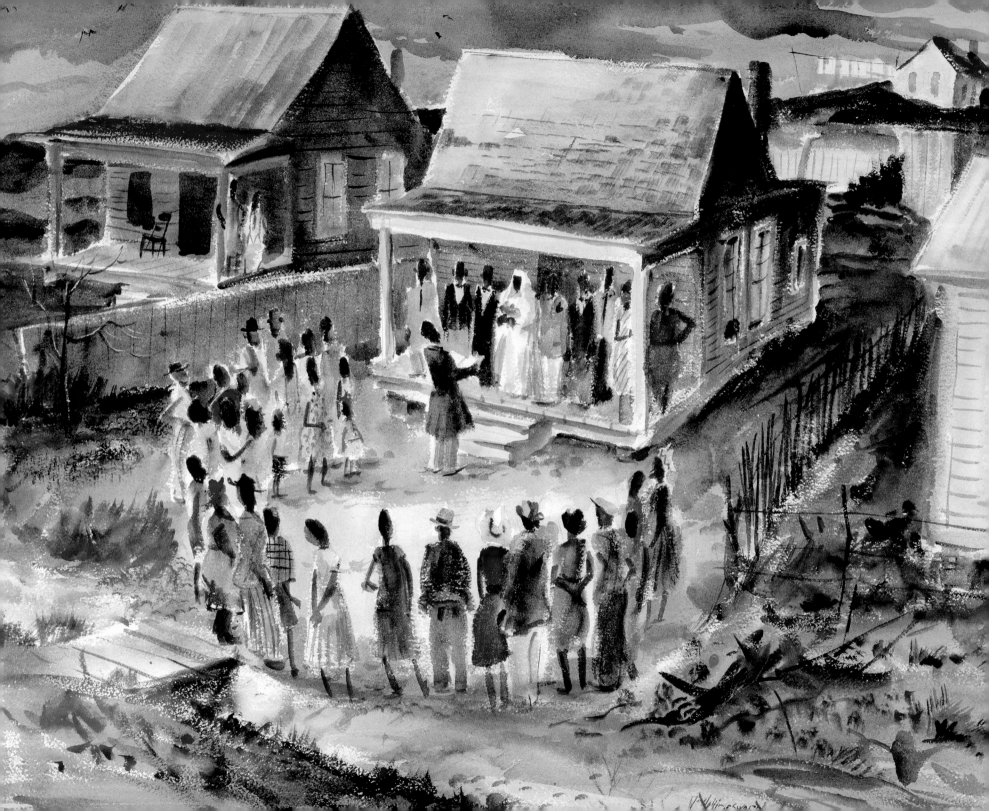

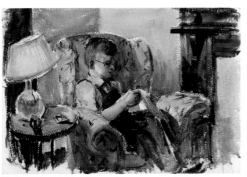

Abandoned Farm
1942
oil on canvas
24 x 30 in.
1987.031

Billy Reading
February 9, 1943
watercolor on paper
16 x 23 in.
1987.090

Annual in Athens, Georgia. Happy Days!!"[68] He also completed a haunting oil painting, *Abandoned Farm*, no doubt inspired by a specific Mississippi farm house, yet it is a work that also symbolizes the many empty, abandoned farm houses and barns that marked the changing landscape of his native state, reflecting the movement of rural populations to the city.

In September 1942, Hollingsworth experienced one of the greatest disappointments of his life, after he enlisted in the United States Navy, only to be discharged weeks later. He described this, briefly, in a journal entry dated September 28. "And so I have had my hitch in Uncle Sam's Navy. I was sent to San Diego, where sure enough, my eyesight bogged me down. So I was given a medical discharge and sent home. My classes at Millsaps started today. Jack [Karl Wolfe] has been drafted: he is already 'in,' but is on a two-week furlough to get his affairs in order. We hate to see him go. In a couple more weeks the leaves should be turning—when that time comes I'll get out and lose myself painting landscapes. Hope so!!"[69] Though understated in his writing, this rejection would continue to trouble him for the remaining years of his life. He was aggravated that his friend and fellow artist had been accepted into the military, while he, though younger, had been rejected due to his eyesight. He remained behind then, working at home in Jackson, as the war effort expanded and factories, airfields, and military training camps were built across Mississippi. Shipyards expanded on the Mississippi Gulf Coast and in New Orleans, Higgins Industries shifted into major production mode, building its famous Higgins and PT boats. In the same year, Mississippi native John McCrady opened his art school in the French Quarter, which would grow and flourish in the post-war years, and he continued to teach the American Scene and "regionalist" styles.

Hollingsworth began the New Year of 1943 working, seemingly optimistic. "Happy New Year—a hope. Day dawned clear, slightly cool. Painted on portrait (Ancestry!) and to Millsaps in afternoon. Start this year with great hopes and confidence. Have progressed so

in painting of late."[70] The next week, when not working on the new painting titled *Sound*, he hung paintings at the Municipal Art Gallery, taught at Millsaps, and soon began working on paintings including *Fury*, *The Letter*, and *The Violinist*. He continued to carve, creating a series of small wooden pieces, and used his carefully rationed gas allocation to drive into the country, to sketch and work on watercolors. On February 10, as he wrote, he had a good day after going "out to paint in a.m., but high winds and lack of enthusiasm brought me home empty handed. Lectured my Millsaps class on the show at the Gallery and home tonight to do a pretty good water color study of Billy sitting reading in a chair. Came today, courtesy of Mr. Engle of Chi. Galleries, a Tribune clipping giving me special mention on 'Brown & Wet' in the American Prize Winners Show at Chicago Arts Club." A week later, on February 17, he celebrated his birthday. "33 years old—and made a good day of it, finishing head study of Mrs. D., meeting class at Millsaps and doing a watercolor which panned out not so well."[71]

In late February he worked on a series of sketches, studies, and paintings of his father, then an elderly and ailing man whose real estate career ended in the Great Depression but whose legacy remained evident in buildings across the city. Early in March, after he packed and shipped fifteen watercolors for an exhibition at the Findlay Galleries in Chicago, he began working on a major new painting, "a long projected picturization of a Negro wedding I had the fortune to witness a few years back." On March 10, 1943, he described his progress: "Today, after doing a color sketch I painted a large wc—21x28—of the wedding, which is now entitled 'It was Cloudy When Evalina Married.' Turned out as well as can tell so soon, swell." Then he traveled to Memphis and attended a jury meeting for the Southern States Art League, at the Brooks Memorial Art Gallery, noting: "A very nice gallery. We selected about 80 paintings and a number of prints."[72] In late March he sketched landscape scenes on Old Canton Road and during April he worked on his father's portrait.

**It was Cloudy
When Evalina Married**
1943
watercolor on paper
22.5 x 30 in.
Collection of Stacy and
Jay Underwood, Jackson, Mississippi

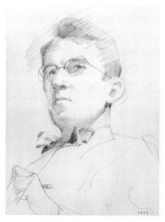

Rural Route
(Old Canton Road, Jackson, Miss.)
1943
watercolor on paper
15 x 22 in. (sight)
Gift of Bernice Flowers Hederman
2005.014

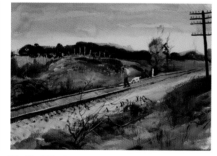

The Coal Hunter
circa 1942
watercolor on paper
19 x 27 in. (sight)
Gift of First National Bank
1963.009

He also worked on two interesting self-portraits, one a direct, frontal image, seen from below, looking up at the artist, and the other showed him from the opposite perspective, seen seated from behind, with no indication of his face or a profile view. He also completed a watercolor titled *The Coal Hunter*, a work depicting a common theme of the Depression and war years, a man accompanied by his dog walking along a railroad bed searching for coal that had fallen off rail cars, and hopefully some warmth for the long winter months. In *The Suitor* (1943), he created one of his most sensitive portraits of this period, depicting a young African American man dressed and seated in a ladder back chair, on a wooden porch, as an ice cream cone melts in his hand—the suitor who is waiting. It is a work reminiscent of the paintings of the Ash Can School of painters, especially Robert Henri (1865–1929), though here created with a gentle Southern touch. A range of accomplished landscapes was completed throughout 1943, including *Rural Route* and *December*, depicting a male figure with a boy and a little girl, walking past a wooden farm house on a dirt road through farm fields, cresting the top of a hill, walking into the light of a glowing sky—a work that seems elegiac, perhaps reflecting the spirit and mood of the artist as he approached the last year of his life.

Throughout the year Hollingsworth worked on studies and paintings of his father and son Bill, immersing himself in the domestic environment he so treasured. Finally, as he noted on September 14, the portrait was finished. "It is the most complete head I've done—the portrait recently worked over of Daddy. The frame (I carved and leafed) is done. All is complete…No one—*no one* could have gotten him as well—it has so much of his fineness, his gentleness, his quietude. I am damned-near satisfied, for a change."[73] It seems that he hoped to capture and contain his father's image, and his spirit, the spirit of the only parent he had known and loved throughout his life. His father's illness and frailty had taken a toll, and almost three months earlier, on June 20, he had died. On December 31, he wrote about the impact of this loss, which continued to haunt him. "The end. A year that has been kind and cruel. My work has gone well; it has sold, been well received, and perhaps is beginning to gain something big. But the loss of Dad can hardly be made up. Still out of this grim hour has come something good—strength, faith, and most important, I guess, a deep profound felt-for-the-first-time gratefulness for being

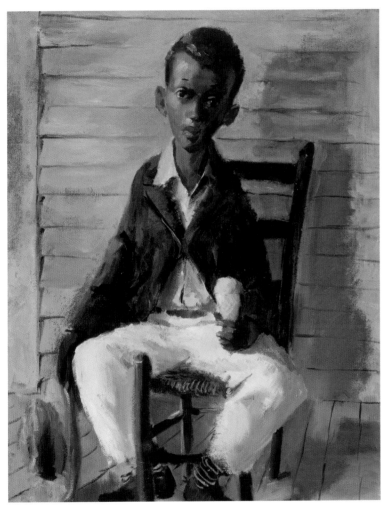

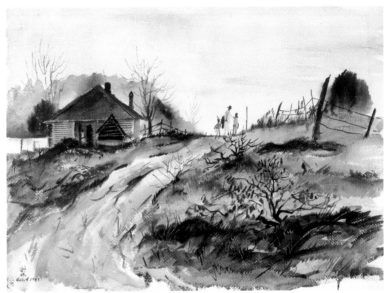

December
December 4, 1943
watercolor on paper
22 x 30 in.
1987.045

The Suitor
September 16, 1943
oil on canvas
30 x 22 in.
1987.044

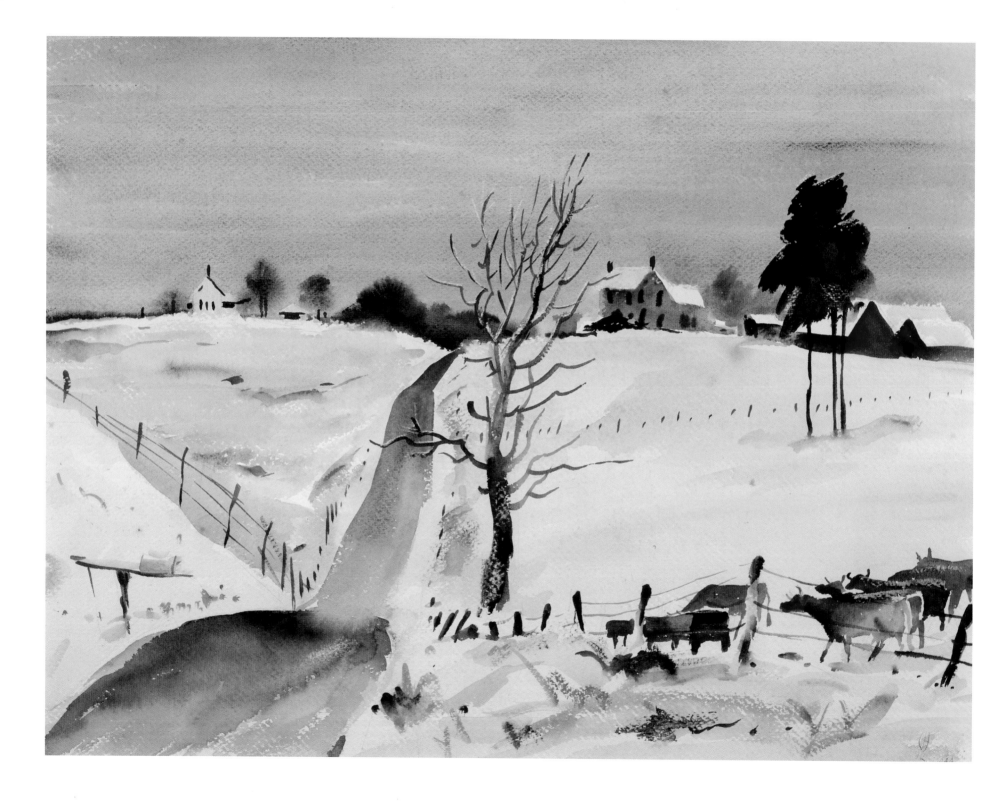

my father's son. So, come on, '44; we are ready!"[74] As Hollingsworth recognized, 1943 was a challenging year emotionally, yet it was also a significant year for his art because he had added a number of notable works to his growing artistic legacy.

On January 1, 1944, he looked to the past and the future. "And so begins a new year. Never do we know what new years may bring. Always, the occasion is, for me, a solemn one." The next day, he worried about getting to work. "And now I must buckle down and get back to paint and canvas. For almost a month now, I have been picture-idle, and must heave to with a vengeance."[75] By the end of the week, he was working and pleased with his progress on a landscape painting and a portrait commission. He also completed a major and highly regarded watercolor painting, *Ah, the Mystery of a Southern Night*, depicting an urban scene under a full Southern moon, viewed from the back of a row of houses on Main Street. It portrays a well-dressed couple strolling under the moonlight, while a group of five black men are hunched under a back porch light in the alley, shooting craps. The moonlit composition recalls many an earlier Southern genre scene, yet it is more contemporary, flavored by the romance and reality evident in and around his native city, as elsewhere in the South during the war years (see oil version p. 24).

He continued to work, painting and sketching many images of his remaining family, as evident in *Jane and Bill* (1944), depicting his wife and son, an image that must have been most reassuring to him in a time of growing doubt and depression. Perhaps it reflected his thoughts of death and he wanted to document his love and the sense of peace and tranquility associated with his family life. Another work, an oil painting titled *The Sermon in the Balcony*, was completed after sketching and developing a number of earlier versions, all inspired by looking down from the mezzanine during a church service, over the head and outspread arms of a young boy, as he listened carefully to the words of Reverend Hewitt in the family church.

A winter scene from 1944, *The Last Time It Snowed*, depicts a rural landscape marked by two farmhouse compounds, which sit at the top of a ridge in a snow covered environment. The clear line of a plowed road divides the scene, as a herd of cattle foraging for food gather inside a fence line. It is cold and winter in Mississippi. Two other images from his final year reflect favorite locations and

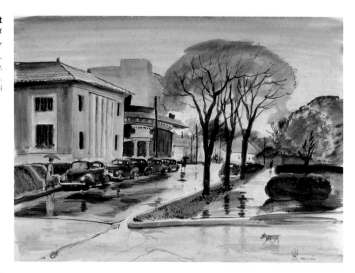

subjects for the artist, both depicted in rainy conditions. *Rain on 49 South* is a watercolor painting depicting a couple walking along, and reflected on, rain-slicked Highway 49, with a farmhouse on the right, behind a fence and line of telephone poles which repeat the lines and curve of the roadway. In contrast, another watercolor dated February 17, 1944, *Wet City Street*, depicts an urban scene, apparently in Jackson, with figures walking along sidewalks in the rain near rows of neatly aligned and carefully parked automobiles, in front of a series of buildings. A small dog, perhaps his terrier "Boy," walks alone in the foreground. These two scenes reflect the range of his interests in the landscapes and populations of Mississippi, as well as marking his love of painting watercolor images on rainy days, showing his mastery of the medium, while using light, reflective surfaces and the unique qualities of watercolor to enhance the mood and atmosphere of these works.

By all accounts, deep in depression and melancholia, apparently drinking heavily as well, Hollingsworth carried substantial burdens in 1944 as the war dragged on, financial pressures continued, and he still mourned the loss of his father. With decreasing faith in the future, he committed suicide, on August 1, 1944. On June 28 he recorded his thoughts and emotions, offering a final portrait of the artist, little more than a month before his suicide.

This is a lonely guy. This me. With a fine wife, a splendid son, I am lonely. With two close friends. In my own hometown, among my own home people. I'm lonely. Perhaps the losing of the one friend in all, the father-mother in one. Perhaps the doing of foolish things. Perhaps the being a painter. But loneliness is here, it thrives, it abounds. And it was meant to be. I can remember loneliness as a companion even as a school-kid....God, make the day come when the painting is so fine, the creation of mine so beautiful, the acclaim so great, that I can say, "It was worth even the loneliness."[76]

And After

1944 to 2012

The Oakley family: (back) Helen and Bob Oakley, Gertrude Oakley, Jane and William Hollingsworth, (front) Billy Hollingsworth, Ray and Brice Oakley, Moline, Illinois, July 4, 1944.

A short time before his death, William Hollingsworth and his family traveled by train to Moline, Illinois, where they visited his wife's family, then continued to Chicago, where they enjoyed visits to familiar sites and showed their son the city. The trip was partially funded with prize money he received after winning a Southern States Arts League competition. Chicago was where Hollingsworth and Jane met, the city where they were trained as artists, and where their son was born in 1933. It was also the city where his parents had lived, and where his sister was born, before the family moved to Jackson. Chicago had always served as an urban touchstone for the Hollingsworth family, just as New York City did for Eudora Welty. In retrospect, it is difficult to determine the impact of the trip on Hollingsworth, and whether or not it influenced his decision to commit suicide after their return to Jackson.

In the year before his death he saw things changing in the state he loved and in his well-structured life there. He ended his teaching at Millsaps College after working to establish its art department with Karl Wolfe. He saw the nature and sensibility of Mississippi change, as the war dominated life in the state, and as the war effort consumed the energy of its residents. Shipyards along the Gulf Coast and Keesler Air Base in Biloxi marked the once bucolic Mississippi coastline. In New Orleans, the Higgins Boat factories produced landing crafts and PT boats in factories where African Americans, women, and even handicapped workers all participated together in the war effort. Closer to home, the city of Clinton housed one of the nation's largest POW camps, where German war prisoners brought the war, and America's enemies, close to his home and studio.

The changing tenor and spirit of life around Jackson made it a very different place than the city where Hollingsworth was raised, and even the one he painted. Today we can see that the art of his final decade captured a unique period of Mississippi history and a unique sense of both time and place, as both Welty and Faulkner also did. Mississippi was not a simple place in those years, but it was his place, one Hollingsworth explored and painted with unique abilities and a native's eye. He was involved in advancing the foundations of the city's modern art world, through the Mississippi Art Association and the Municipal Art Gallery, where he and Wolfe devoted so much time and effort to create an environment that was conducive to advancing the arts in Mississippi and the South.

Most important though was his art of this period, which reflects his vision and sentiments about the state and its people. He traveled between the urban environment of the state's largest city and the surrounding rural regions where much of the population lived before the war. He painted the residents and lively activities of Farish Street, the state capitol building, traffic on rainy streets, downtown crowds, and other scenes of urban life. At the same time, he painted images of timeless agricultural environments—barns, farm houses, fields, pastures, and winding, hilly country lanes. His sensibilities and insights about both the urban and the rural environments were unique. In his landscapes, he sought simple, seemingly ordinary scenes, yet what he painted was anything but ordinary. He developed a subtle and sophisticated sense of color. His feeling for the landscape of Mississippi seems to reflect earlier traditions of the American Landscape school, and follows its transition into the twentieth century, as evident in the works of artists like George Inness (1825–1894) and Elliott Daingerfield (1859–1932), as well as in the works of John Marin, Georgia O'Keeffe (1887–1986), Charles Burchfield, and others.

Hollingsworth felt alone and depressed about many things in his last year: the death of his father in 1943, the ongoing course of the war, his inability to serve in the military, and the lack of national acclaim and recognition he desired as an artist, blaming this on his location in the South and his distance from major art enters such as Chicago and New York. Hollingsworth was far from alone, however, in these feelings and in his lack of national recognition as a Southern, or a regional artist, working in America in the early 1940s. Much of that, of course, was related to the nation's focus on the war and the home front war effort. Yet some of the nation's leading artists of the 1930s, including those who had been designated leaders of the "regionalist" movement, experienced a similar sense of rejection

Billy and Jane in Chicago, July 1944.

and isolation and questioned the value of their art and vision. Grant Wood, for example, suffered a wide range of difficulties after returning to live and work in Iowa. His *American Gothic* had become an iconic American image during the 1930s, yet by the early 1940s his stature and reputation were in question. When he died, before Hollingsworth, on February 12, 1942, he felt isolated and rejected. John Steuart Curry, another designated leader of the "regionalist" movement, had encountered a range of disappointments, including controversies over his murals for the Kansas Statehouse. He died on August 29, 1946, equally alone, isolated, and confused about his place in the American art world. This was a dramatic shift from his earlier success.

Thomas Hart Benton was the only survivor of this "regionalist" triumvirate, yet he too underwent a difficult transformation in the perception of his art and his philosophies. He also encountered controversies in his murals for the Missouri State Capitol, which he viewed as an accurate historical record of his native state. After being one of the most recognized artists in America and one of its most influential muralists, in later years he faced criticism from Clement Greenberg and Harold Rosenberg, advocates for the New York School, and Abstract Expressionists like Jackson Pollock. Benton declared that it was "best to outlive your enemies," which he in fact did, living long enough to enjoy a revival of interest and appreciation of his art during the 1960s and 1970s, accompanied by a number of mural commissions, and a series of revisionist exhibitions and publications devoted to his career. To some extent, in his art and writings, he was able to rewrite his own place in art history, which Hollingsworth, Curry, Wood, and many artists of that era were unable to do.

By 1946, with the war over and the nation transitioning to a new postwar economy, the art world was also in transition. Hollingsworth—like Curry and Wood—was no longer a presence in the art world. Notably, it was in this year that Thomas Hart Benton, who was no longer a pivotal public figure, offered his reflections upon the changes evident in the American art world, as well the loss of Curry and Wood. In some respects, his words addressed the larger context and lack of recognition associated with William Hollingsworth and his art.

Grant Wood is dead and John Curry is dead. They were closer to me in basic attitude of mind, in their social and aesthetic philosophies, than all other artists. Together we stood for things which most artists do not much believe in. We stood for an art whose forms and meanings would have direct and easily comprehended relevance to the American culture of which we were by blood and daily life a part...We hoped to build our "universals" out of the particularities of our own times and our own places, out of the substances of our actual lives as most great artists of the world's past have.[77]

In 1958, fourteen years after his death, a significant exhibition of Hollingsworth's works was presented at the Jackson Municipal Art Gallery, the space where he had dedicated so much of his time working on projects related to the art and artists of Mississippi. Eudora Welty's reflections on her colleague were prompted by a visit to that 1958 memorial exhibition. "William Hollingsworth knew this world; the paintings will tell you how well. When you see again the examples of his work, you keep thinking of what he loved: the hour of the day; the day of the week; the month of the year; water; sky; the road going over the hill. All might have been a phenomenon to his eyes—all Mississippi." She continued, listing the specific qualities of his paintings. "He loved the violet spaces hanging beyond the last ridge, the rich red gullies, the loneliness of telephone poles marching away, the hush of snow, the warm streaming lights of city rain; and he kept going back to festivals of life that would suddenly break out at a country crossroads, the figures that might have sprung out of our Mississippi clay in simple spontaneous combustion."[78]

Another significant exhibition of Hollingsworth's art was presented in 1981, three years after the new Mississippi Museum of Art opened in 1978. It was accompanied by a major publication, *Hollingsworth: The Man, the Artist, and His Work*, edited by his wife Jane Hollingsworth and the first volume in the Mississippi Art Series, a new imprint of the University Press of Mississippi. Jane Hollingsworth served as the keeper of his artistic legacy in the decades after his death in 1944. In addition to featuring a range of his paintings, watercolors, and sketches from his extensive archives,

the book included selections of his writings and journal entries, offering glimpses into the artist and his process of critical thinking.

A growing interest in the art and culture of the South (a development that may have surprised Hollingsworth), became evident in the years after the American Bicentennial in 1976. In 1977, the Center for the Study of Southern Culture was founded on the campus of Hollingsworth's old school, the University of Mississippi, and it later published *The Encyclopedia of Southern Culture* (1989). In 1978, after decades of planning and effort, the Mississippi Museum of Art opened its doors in downtown Jackson, bringing a larger focus to the art and artists of the state. In 1983, a major exhibition devoted to Southern art, *Painting in the South: 1564 to 1980*, was organized by the Virginia Museum of Fine Arts and traveled across the country, followed in 1984 by *The Art and Artists of the South, The Coggins Collection*, organized by the Columbia Museum of Art, which also traveled extensively. Each exhibition was accompanied by a scholarly catalogue.

Following the death of Jane Hollingsworth in 1986, the Mississippi Museum of Art organized an exhibition titled *A Retrospective: The Works of William R. Hollingsworth, Jr.*, which opened in 1987. It was based upon the significant gift of Hollingsworth's art that Jane Hollingsworth had bequeathed to the museum. As then director Alex Nyerges noted, "Unknown to even her closest friends, Jane Hollingsworth, the late widow of William Hollingsworth, Jr., guarded over what can best be described as a priceless treasure of artwork. After Hollingsworth's suicide in 1944, Jane carefully stored nearly 300 works by her husband in her home in Belhaven, a quaint older Jackson neighborhood. The entire collection of watercolors, paintings and drawings was never seen by the public and only on rare occasions would a work be lent to an exhibit. Never did anyone realize or suspect the extent of Jane Hollingsworth's private treasure."[79] Based upon this collection, the museum organized a series of exhibitions. Some of these traveled across the state, including *William Hollingsworth: The Back Road Home* (1998) and *William Hollingsworth: My Mississippi* (2001).

In 1996, Hollingsworth's painting, *Mississippi Saturday Night*, was included in *Art in the American South: Works from the Ogden Collection* by Randolph Delahanty. He was a featured artist in Patti Carr

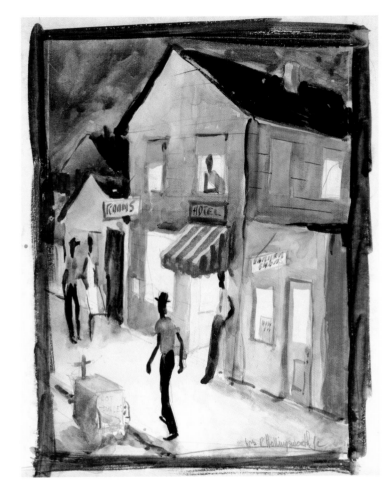

Mississippi Saturday Night
1940
watercolor on paper
9.5 x 7.5 in.
Collection of Ogden Museum of Southern Art,
New Orleans, Louisiana
Gift of the Roger H. Ogden Collection

The Gentle Snow
January 15, 1944
watercolor on paper
15.75 x 22.75 in. (sight)
1987.086

Black's *Art in Mississippi: 1720–1980*, published by the University Press of Mississippi in 1998, and was included in *Passionate Observer: Eudora Welty among Artists of the Thirties*, published by the Mississippi Museum of Art (2002), accompanying an exhibition of the same name. In 2002, the book *On William Hollingsworth, Jr.*, by Eudora Welty, was published by the University Press of Mississippi. In 2003, William Hollingsworth's art, drawn from the Roger Houston Ogden Collection, was featured in the Grand Opening of Stephen Goldring Hall at the Ogden Museum of Southern Art in New Orleans. And in 2007, when the Mississippi Museum of Art opened its new building in Jackson, Hollingsworth was one of the featured artists in one of its grand opening exhibitions.

Karl Wolfe, the close friend and professional colleague of William Hollingsworth offered his conclusions on the life and art of Hollingsworth, observing that Hollingsworth had to paint, had to create the works that formed his final legacy. "He had obsessions to say in his own terms something of the feelings that welled inside him, something he felt about the wild reaches of the sky, the air that's breathed by all that lives, the richness of the earth, the goodness of things, and with rare honesty, something of the dark struggles with which man is tortured."[80] Eudora Welty, who was a central figure in that intimate Jackson art world of the 1930s and 1940s and knew Hollingsworth well, was perhaps best equipped to offer a final word on the artist and his work. "I think William Hollingsworth had, besides his other wonderful gifts, the gift of true gaiety that is a paradox; for even despair never rules it out, and maybe informs it… His was a most personal vision, and isn't it this, perhaps, that gives enduring beauty to his work? In each of these paintings, what we know the surest and value the most is that nobody else could have seen the world this way, or will see it so again; that only William Hollingsworth, happening to travel the place we live, has seen this, and made it true."[81]

J. Richard Gruber, Ph.D.
Director Emeritus
Ogden Museum of Southern Art
University of New Orleans

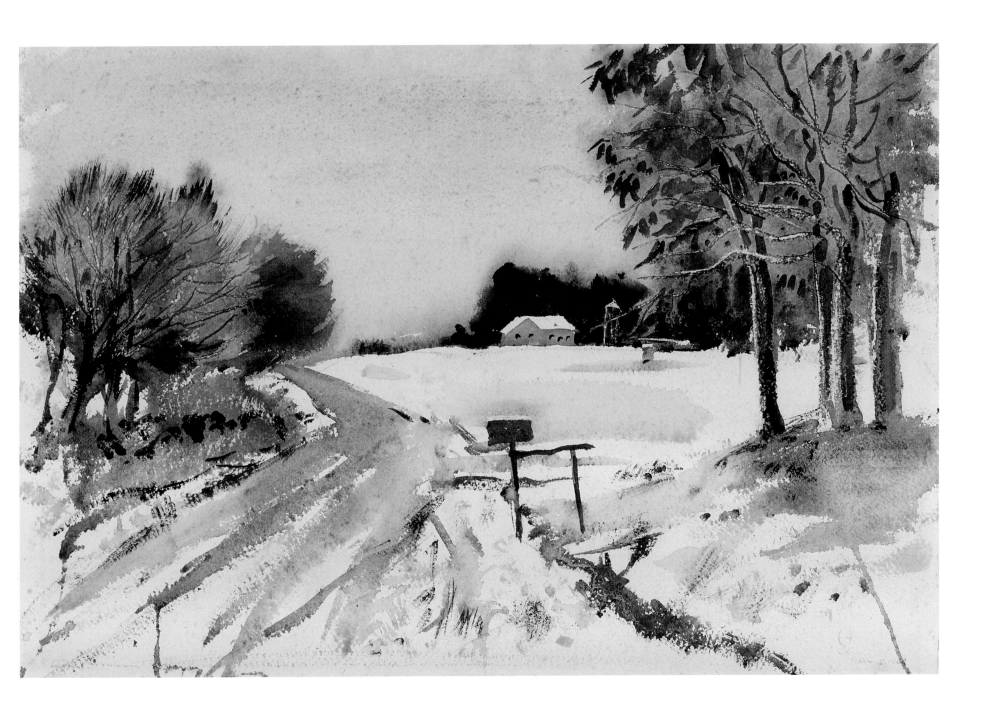

1 Eudora Welty, *On William Hollingsworth, Jr.* (Jackson: University Press of Mississippi, 2002), 5–6.

2 Hunter Cole, "Afterword: Art at Home," in Welty, *On William Hollingsworth, Jr.*, 22–23.

3 See Hunter Cole and Seetha Srinivasan, "Eudora Welty and Photography: An Interview," in Eudora Welty, *Eudora Welty Photographs* (Jackson: University Press of Mississippi, 1989), xxvi–xxvii.

4 See Patti Carr Black, "Back Home in Jackson" in *Passionate Observer: Eudora Welty among Artists of the Thirties*, ed. René Paul Barilleaux (Jackson: Mississippi Museum of Art, 2002 and 2003), 43.

5 Cole and Srinivasan, "An Interview," xxv.

6 See Suzanne Marrs, *Eudora Welty: A Biography* (Orlando: Harcourt Books, 2005), 35–137.

7 Welty, *On William Hollingsworth, Jr.*, 7.

8 Black, "Back Home in Jackson," 39–52.

9 Cole, "Afterword," 23.

10 Welty, *On William Hollingsworth, Jr.*, 5.

11 Ibid., 30.

12 O. C. McDavid, introduction to *Hollingsworth, The Man, the Artist, and His Work*, ed. Jane Hollingsworth (Jackson: University Press of Mississippi, 1981), 9 [hereafter *Hollingsworth*].

13 Marrs, *Eudora Welty*, 1–6.

14 The Federal Writers' Project of the Works Progress Administration, *Mississippi: The WPA Guide to the Magnolia State* (1938; repr., Jackson: University Press of Mississippi, 2009), 209.

15 Hunter Cole, "William Hollingsworth: An Artist of Joy and Sadness," *Mississippi History Now* (November 2005), *http://mshistory.k12.ms.us/articles/37/william-hollingsworth-an-artist-of-joy-and-sadness*.

16 Marrs, *Eudora Welty*, 14–16. The Eudora Welty House is operated by the Mississippi Department of Archives and History, http://www.mdah.state.ms.us/welty.

17 Cole, "William Hollingsworth: An Artist of Joy and Sadness."

18 Ibid.

19 Marrs, *Eudora Welty*, 4–5.

20 Ibid., 14–15.

21 The Federal Writers Project, *WPA Guide*, 209.

22 Ibid., 221.

23 See chronology in Richard Wright, *Black Boy* (New York: Harper Perennial Modern Classics, 2006), 385–89.

24 Ibid., 169.

25 Quoted in James C. Cobb, *Away Down South: A History of Southern Identity* (New York: Oxford University Press, 2005), 149.

26 *Hollingsworth*, 9.

27 Marrs, *Eudora Welty*, 11.

28 The Federal Writers Project, *WPA Guide*, 254–57.

29 Ibid., 254.

30 Dominic A. Pacyga, *Chicago: A Biography* (Chicago: University of Chicago Press, 2009), 112–273.

31 John Barry, *Rising Tide: The Great Mississippi Flood of 1927 and How It Changed America* (New York: Simon & Schuster Paperbacks, 1998), 417.

32 Isabel Wilkerson, *The Warmth of Other Suns: The Epic Story of America's Great Migration* (New York: Random House, 2010), 9–11.

33 Wright, *Black Boy*, 261–62.

34 Wanda M. Corn, *Grant Wood: The Regionalist Vision* (New Haven, CT: Yale University Press, 1983), 148–49.

35 See Twelve Southerners, *I'll Take My Stand: The South and the Agrarian Tradition* (Baton Rouge: Louisiana State University Press, 1977) and Thomas W. Cutrer, *Parnassus on the Mississippi: The Southern Review and the Baton Rouge Literary Community, 1935–1942* (Baton Rouge: Louisiana State University Press, 1984).

36 Pacyga, *Chicago*, 264–65.

37 Neil Harris, "Old Wine in New Bottles: Masterpieces Come to the Fairs," in Robert W. Rydell and Laura Burd Schiavo, *Designing Tomorrow: America's World's Fairs of the 1930s* (New Haven, CT: Yale University Press, 2010), 42.

38 Ibid., 44.

39 See Art Institute of Chicago, *Catalogue of A Century of Progress Exhibition of Paintings and Sculpture, Lent from American Collections* (Chicago: Art Institute of Chicago, 1933), 120.

40 Harris, "Old Wine," 48.

41 Kathleen A. Foster, Nanette Esseck Brewer, and Margaret Contompasis, *Thomas Hart Benton and the Indiana Murals* (Bloomington: Indiana University Art Museum, 2008), 10–11.

42 Ibid., 33.

43 Regarding the growing importance of *Life* in these years, see Wendy Kozol, *Life's America* (Philadelphia: Temple University Press, 1994).

44 See Patti Carr Black, *Art in Mississippi: 1720–1980* (Jackson: University Press of Mississippi, 1998), 171–74.

45 Wright, *Black Boy*, 391–93.

46 McDavid, introduction to *Hollingsworth*, 10–11.

47 See Patricia Junker, ed., *John Steuart Curry: Inventing the Middle West* (New York: Hudson Hills Press, 1998), 230–31 and M. Sue Kendall, *Rethinking Regionalism: John Steuart Curry and the Kansas Mural Controversy* (Washington, D.C.: Smithsonian Institution Press, 1986).

48 Quoted in Charles C. Eldredge, *John Steuart Curry's Hoover and the Flood: Painting Modern History* (Chapel Hill: University of North Carolina Press, 2007), ix.

49 Black, *Art in Mississippi*, 189–90.

50 See "New Deal/WPA Art in Mississippi," New Deal Art During the Great Depression, *http://www.wpamurals.com/mississip.htm*.

51 Francis V. O'Connor, "Framing Time in Expressive Spaces: Eudora Welty's Stories, Photographs, and the Art of Mississippi in the 1930s," in *Passionate Observer: Eudora Welty*, 66.

52 Cole, "Afterword," 26–27.

53 Karl Wolfe, *Mississippi Artist: A Self-Portrait* (Jackson: University Press of Mississippi, 1979), 54.

54 Wolfe, quoted in Cole, "Afterword," 29.

55 Cole, "William Hollingsworth: An Artist of Joy and Sadness."

56 The Federal Writers Project, *WPA Guide*, 22, 30.

57 Cole, "William Hollingsworth: An Artist of Joy and Sadness."

58 See McDavid, introduction to *Hollingsworth*, 11.

59 See Rydell and Schiavo, *Designing Tomorrow*; Larry Zim, Mel Lerner, and Herbert Rolfes, *The World of Tomorrow: The 1939 New York World's Fair* (New York: Harper & Row, 1988); and David Gelernter, *1939: The Lost World of the Fair* (New York: Avon Books, 1995).

60 McDavid, introduction to *Hollingsworth*, 12.

61 Quoted in Welty, *On William Hollingsworth, Jr.*, 25.

62 *Hollingsworth*, 17–18.

63 Ibid., 19.

64 Ibid., 20, 22.

65 Ibid., 27, 42.

66 Ibid., 27.

67 Ibid., 30, 31, 33.

68 Ibid., 36.

69 Ibid., 36-37.

70 Ibid., 39.

71 Ibid., 48–49.

72 Ibid., 57.

73 Ibid., 76.

74 Ibid., 100.

75 Ibid., 103.

76 Ibid., 142.

77 Thomas Hart Benton, "John Curry," *University of Kansas City Review*, vol. 13, no. 2 (Winter 1946).

78 Welty, *On William Hollingsworth, Jr.*, 3.

79 Alexander Lee Nyerges in exhibition guide, *A Retrospective: The Works of William R. Hollingsworth, Jr.* (Jackson: Mississippi Museum of Art, 1987).

80 Quoted in McDavid, introduction to *Hollingsworth*, 13.

81 Welty, *On William Hollingsworth, Jr.*, 6-7.

The Hollingsworth family, 1943.

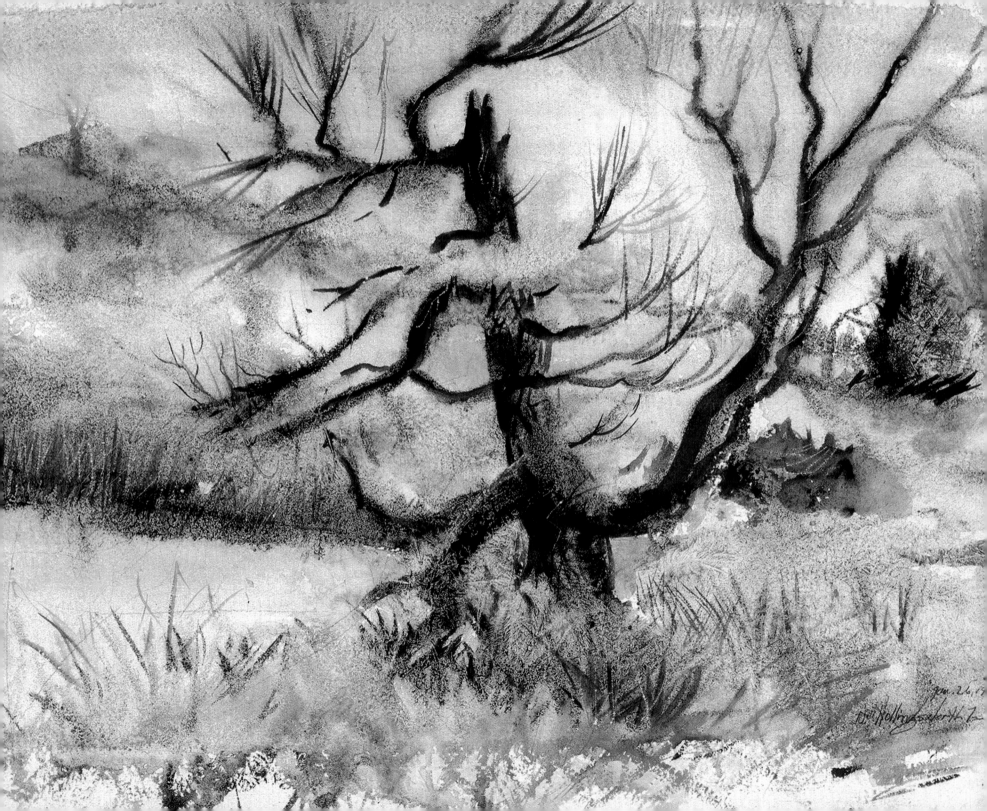

A Timeline

of the Art and Life of
William R. Hollingsworth, Jr.

1896 March 24—Parents (William Robert Hollingsworth, Sr. (1865–1943) and Willie Belle Vanzile (1874–1910)) marry, Vicksburg, Mississippi

1897 March 4—Sister Isabel is born, Chicago, Illinois

1898 Parents and sister (Willie Belle and William Hollingsworth, Sr., and Isabel) move from Chicago to Jackson, Mississippi

1904 Parents and sister (Willie Belle and William Hollingsworth, Sr., and Isabel) move to 754 North President Street, Jackson

1910 February 17—William Robert Hollingsworth, Jr., is born at 754 North President Street, Jackson

December 9—Mother (Willie Belle Vanzile Hollingsworth) dies, Jackson

1912 March 2—Celia Jane Oakley is born, Moline, Illinois

1916 Begins primary school at Jefferson Davis Grammar School, 750 North Congress Street, Jackson

1922 Sister Isabel marries Fred A. Tyson, who becomes William Robert Hollingsworth, Sr.'s business partner at Hollingsworth & Tyson Real Estate

1928 Travels with father to Chicago to meet cartoonist Carey Orr at the *Chicago Tribune*

Graduates from Central High School, 359 North West Street, Jackson

Enrolls at University of Mississippi, Oxford

1930 Enrolls at School of the Art Institute of Chicago

1932 September 20—Marries Celia Jane Oakley (1912–1986), Chicago

1933 April—First Prize Print and Second Prize Oil, Amateur Show, Mississippi Art Association, Municipal Art Gallery, Jackson

July 6—William Robert Hollingsworth III is born, Moline, Illinois

Solo exhibition of lithographs, Cary Art Club Exhibits, Fitzhugh Hall, Belhaven College, Jackson

1934 Graduates from School of the Art Institute of Chicago

Moves to 763 Lorraine Street, Jackson

July—Solo exhibition of watercolors, alongside photographs by Eudora Welty and Hubert Creekmore, Mississippi Art Association, Municipal Art Gallery, Jackson

Works as clerk for Federal Emergency Relief Administration until 1939, Tower Building, Jackson

Solo exhibition of oils, watercolors, and lithographs, Mississippi Art Association, Municipal Art Gallery, Jackson

October—First Prize Landscape and Second Prize Portrait at Mississippi State Fair, Jackson

November—Silver Ribbon for *Vagabond's Respite*, *Twenty-third Annual Exhibition*, Mississippi Art Association, Municipal Art Gallery, Jackson (a still life is also included)

1935 June—*Annual Exhibition of American Art*, Cincinnati Museum of Art, Ohio (*Black and White* is included)

October—All-American Show, Art Institute of Chicago (*Black and White* is included)

November—Gold Medal for *Tired, Oh, Lord, Tired*, *Twenty-fourth Annual Exhibition*, Mississippi Art Association, Municipal Art Gallery, Jackson

Moves to 763 Madison Street, Jackson

1936 October—Third Prize Landscape, Mississippi State Fair, Jackson

Annual Exhibition of American Art, Cincinnati Museum of Art, Ohio (*Tired, Oh, Lord, Tired* is included)

Silver Medal for *We Who Wait*, *Twenty-fifth Annual Exhibition*, Mississippi Art Association, Municipal Art Gallery, Jackson (*Portrait of Bill* is also included)

Gold Medal Oil, Mississippi Art Association, Municipal Art Gallery, Jackson

Moves to 754 North President Street, Jackson

1937 July 16–31—*Second Annual Exhibition of American Art*, New York City (*Black and White* is included)

October—Purchase Prize for *Sudden Shower*, Mississippi State Fair, Jackson

William Tuthill Prize for *Siesta*, *International Water Color Exhibition*, Art Institute of Chicago (*Black and White* is also included)

Annual Exhibition of American Art, Cincinnati Museum of Art, Ohio (*Mid Afternoon* and *Wimpy's Inn* are included)

Becomes member of Chicago Galleries Association

1938 March 1—*Annual Exhibition of Contemporary American Sculpture, Watercolors, Drawings and Prints* opens at Whitney Museum of American Art, New York (watercolor depicting Farish Street is included)

October 1–22—Three-person exhibition at Chicago Galleries Association, with Arnold E. Turtle, Chicago and Rose K. Boettcher, Evanston (*Reading Light*, *I Seen a Ghost*, and *Afternoon Sun* are included, among others)

October—First Prize "Other than Named" and Third Prize Portrait, Mississippi State Fair, Jackson

Solo exhibition of watercolors, Davenport Municipal Art Gallery, Iowa

1939 Sets up home studio, begins to paint full time

September—Solo exhibition of watercolors and oils, Mississippi Art Association, Municipal Art Gallery, Jackson

September—Exhibition, Los Angeles County Fair, California (*Rain Cloud Over the Tracks* is included)

November—*Forty-second Annual Exhibition of the Baltimore (Maryland) Water Color Club* (*Rain Cloud Over the Tracks* and *Summer Morning* are included)

1940 February 9–25—The New York Water Color Club and The American Water Color Society *Combined Exhibition* at the Fine Arts Building, New York City (*The Lake* is included)

February 9—*Annual Exhibition* opens, Mississippi Art Association, Municipal Art Gallery, Jackson (two landscapes are included)

April 4–30—*First Exhibition of Arts and Artists Along the Mississippi*, Davenport Municipal Gallery, Iowa (*Black and White* oil is included)

August—Solo exhibition, Delgado Museum of Art, New Orleans

September—*Sixteenth Exhibition* at Delgado Museum of Art, New Orleans, Louisiana (twenty-three watercolors are included)

November 25–December 1—*National Art Week Exhibition*, Mississippi Art Association, Municipal Art Gallery, Jackson (five works are included; holds open house at his studio Friday, November 29)

Seventh Award for *Drear*, IBM's Gallery of Science and Art, New York World's Fair

National Water Color Exhibition, Oakland Art Gallery, Municipal Auditorium, California (*The Neighbor* is included)

Eighteenth Circuit Exhibition, Southern States Art League (*November Brown* and *Old Church Building* are included)

November—Exhibition, Pineville, Louisiana (twenty-two watercolors are included)

1941 February—Gold Ribbon, *Annual Exhibition*, Mississippi Art Association, Municipal Art Gallery, Jackson (*The Hunt Breakfast* and *The Countryman* are included)

March 2–24—*Oils and Watercolors of William Hollingsworth, Jr.*, Presser Hall, Illinois Wesleyan University, Bloomington

April 3–30—*Second Exhibition of Arts and Artists Along the Mississippi*, Davenport Municipal Gallery, Iowa (*The Rains* oil is included)

May 5—Federal Works Agency Public Building Administration accepts the watercolor *Barber Shop—Black* for "The Decoration of Marine Hospitals," P.H.S. Hospital in Lexington, Kentucky

May—*Water Colors By Two Southern Artists Leroy Jackson and William R. Hollingsworth*, Fine Arts Building, Athens, Georgia (twenty-two works by Hollingsworth in total are shown, including *Farish Street Photographer* and *Six A.M.*)

June 23—Honorable Mention, *National Water Color Exhibition* opens, San Diego Fine Arts Gallery, California (*South Rain* is included)

Nineteenth Circuit Exhibition, Southern States Art League (*The Hunt Breakfast* oil and *The Riding Academy* watercolor are included)

Fall—Initiates art department at Millsaps College, Jackson and teaches there through 1943

October—*National Water Color Exhibition*, Oakland Museum, California (*Blacksmith Shop* is included)

National Art Week community exhibition, Mississippi Art Association, Municipal Art Gallery, Jackson (sells *Melon Carriers* watercolor to IBM from this exhibition)

1942 February—Exhibition in library, University of Notre Dame, Indiana, sponsored by architecture department

April 4–30—Honorable Mention for *The Coal Hunter*, *First Annual National Watercolor Exhibition*, Mississippi Art Association, Municipal Art Gallery, Jackson (*Spring in the Offing* is also included)

April 13—Exhibition of work by William Hollingsworth and Karl Wolfe opens at Kennington's department store, Oxford, Mississippi

Dual Prize Oil, with Karl Wolfe, Mississippi Art Association

Blanche S. Benjamin Prize for *Brown and Wet*, *Twenty-second Annual Exhibition*, Southern States Art League, Athens, Georgia (*Sunrise Serenade* is also included)

Special Mention, *American Prize Winners Show*, Chicago Arts Club

August—Enlists in navy, discharged due to bad eyesight two weeks later

September—Exhibition of work by Karl Wolfe and William Hollingsworth, Brooks Memorial Art Gallery, Memphis, Tennessee (thirty-four watercolors are included)

October—Solo exhibition, Mississippi Art Association, Municipal Art Gallery, Jackson

Sells *The Rains* to film actress Maureen O'Hara

1943 February 3–25—*American Prize Winners*, The Arts Club of Chicago (*Brown and Wet* and *Weighing the Pick* are included)

March—Serves as juror for Southern States Art League exhibition

March 24–April 14—The American Watercolor Society *76th Annual Exhibition* at the National Academy Galleries, New York City (*The Lake* is included)

April 1–30—*Second Annual National Water Color Exhibition*, Mississippi Art Association, Municipal Art Gallery, Jackson (*The Crossroads* and *Brown's Hill* are included)

April—Exhibition of watercolors, Findlay Galleries, Chicago

June 20—Father (William Hollingsworth, Sr.) dies, Jackson

October 9–27—Exhibition, Chicago Galleries Association

The Sound and the Fury exhibition of war scenes, Mississippi Art Association, Municipal Art Gallery, Jackson

Exhibition of oil paintings, Oakland, California (*The Violinist* is included)

Twenty-first Circuit Exhibition, Southern States Art League (*The Railway Cut* is included)

Annual National Water Color Exhibition, Oakland Art Gallery, California (*Home on Furlough* is included)

1944 January 23—Serves on jury for *Annual Exhibition of Oil Paintings*, Mississippi Art Association, Municipal Art Gallery, Jackson

February 1–28, *Annual Exhibition of Oil Paintings*, Mississippi Art Association, Municipal Art Gallery, Jackson (*Pitcher with Fruit* is included)

March—Group exhibition, Ferargil Galleries, New York City (five watercolors are included)

Honorable Mention with Distinction, *Third Annual National Water Color* Exhibition, Mississippi Art Association, Municipal Art Gallery, Jackson (*Rainshine* is included)

Rhodes S. Baker Memorial Prize for *Ah, The Mystery of a Southern Night* oil, *Twenty-fourth Annual Exhibition*, Southern States Art League

July—Vacations with family in Moline and Chicago

August 1—Dies, 754 North President Street, Jackson

September 11—*William R. Hollingsworth Retrospective* opens, Findlay Galleries, Chicago

November 1–15—*Memorial Exhibit*, Brooks Memorial Art Gallery, Memphis

November 15—*William R. Hollingsworth Memorial Exhibit* closes, Fitzhugh Hall, Belhaven College

1945 *Portrait of America* by Aimee Crane (New York: Hyperion Press, 1945) includes watercolor *Activities at the Crossroads*

March 7—Mississippi Art Association passes resolution in annual assembly; in it they "express…appreciation of [Hollingsworth's]

untiring efforts and pay tribute to him as an artist and a teacher"

October 1–November 26—*William Hollingsworth Memorial Show*, Mississippi Art Association, Municipal Art Gallery, Jackson

1946 January 8–22—Exhibition at Howard Library (location unknown)

October 6–11, 1946(?)—*Mississippi Capitol Street Art Show*, Jackson (ninety stores participate)

October 18–November 3—Exhibition, Wesleyan Conservatory, (location unknown)

Fifth Annual National Water Color Exhibition, Mississippi Art Association, Municipal Art Gallery, Jackson (*That Place* is included)

1949 September 1–30—*Second Memorial Exhibition of William R. Hollingsworth, Jr.*, Mississippi Art Association, Municipal Art Gallery, Jackson

Francis Steegmuller's *New York Times Book Review* of *The Golden Apples* by Eudora Welty features the watercolor *In Mississippi*

1950 March 10–12—Exhibition, Confederate Memorial Building, Greenwood, Leflore County Art Association

April 8–30—*Water Color Paintings by William R. Hollingsworth, Jr.*, Spring Festival of Fine Arts *Invitational Exhibition*, Department of Art, Academic Hall, Mississippi State College for Women, Columbus (seventeen paintings are included)

October 1—Exhibition of paintings opens, Allison's Wells spa, Madison County, Mississippi (curated by Karl Wolfe, director of Allison's Art Colony)

1952 February 1–29—*An Exhibition of Mississippi's Patrons of Art*, Mississippi Art Association, Municipal Art Gallery, Jackson (eleven works are included)

September 3—Exhibition opens and is on view for three weeks, Greenbrook Flowers, Morgan Center, Jackson

1956 October 7–28—*Hollingsworth Memorial Show: Watercolors by William R. Hollingsworth, Jackson, Mississippi*, Lauren Rogers Museum of Art, Laurel, Mississippi

1958 September 7–21—*1st Annual William Hollingsworth Memorial Exhibition*, Mississippi Art Association, Municipal Art Gallery, Jackson

1959 November 4–25—*A Memorial Exhibition: Watercolors by William R. Hollingsworth, Jackson, Mississippi*, Mary Buie Museum, Oxford, Mississippi

1962 March 25—*Memorial Art Exhibition of the Work of William*

Hollingsworth, Jr. opens, Steele Cottage, Vicksburg (watercolors from private collections are included)

May—*William Hollingsworth Exhibit*, Forum Room, Library, Millsaps College, Jackson

September 1–28—*Exhibition of Watercolors by William Hollingsworth, Jr.*, Lauren Rogers Museum of Art, Laurel

October—*Exhibition of Watercolors by William Hollingsworth, Jr.*, Marsh Fine Arts Building, University of Southern Mississippi, Hattiesburg

1963 March—Four works by William Hollingsworth are on view at Steele Cottage, Vicksburg (*Self-Portrait, The Suitor, Sundown Chatter*, and *The Peanut Seller* are included)

March—Exhibition, B. C. Rogers Student Center, Mississippi College, Clinton

November—Exhibition of paintings, Bank of Forest Art Gallery, Forest, Mississippi

1964 March 18–April 19—*Exhibition of Paintings by William R. Hollingsworth*, Lauren Rogers Museum of Art, Laurel

September 27–October 16—Exhibition, Hinds Junior College, Raymond, Mississippi

1966 January 20–29—Exhibition of sketches, New Stage Theatre's art gallery, Jackson

April 24–May—Exhibition, Mississippi Arts Festival, Old Capitol Museum, Jackson

May 8–31—*Exhibition of Sketches by William Hollingsworth*, Lauren Rogers Museum of Art, Laurel

1967 January—*The Paintings of the Late William Hollingsworth*, Bryant Galleries, Jackson

July/August—*The Delta Review* magazine features *Activities at the Crossroads* on cover of 150th anniversary issue

1969 February—*The Artist's Son*, Mississippi Art Association, Municipal Art Gallery, Jackson

1970 April 5–26—*The Artist's Son*, Lauren Rogers Museum of Art, Laurel

October—Exhibition, Mississippi College, Clinton

1971 Early April–May 9—*Watercolors by William R. Hollingsworth*, Meridian Museum of Art, Mississippi

October 29—*Paintings by Hollingsworth* opens, Hinds Junior College, Raymond, Mississippi

1972 January 10–28—Group exhibition from local collectors, Hinds Junior College, Raymond (*The Violinist* is included)

March 5–24—Exhibition at Fire House Gallery, Vicksburg

September 27–October 7—First exhibition of sculptures by Jane Hollingsworth, New Stage Theatre, Jackson

1974 April—Solo exhibition of paintings during National Library Week, Mississippi Department of Archives and History, Jackson

1981 *Hollingsworth: The Man, the Artist, and His Work*, ed. Jane Hollingsworth, with introduction by O. C. McDavid is published (Jackson: University Press of Mississippi, 1981)

November—Solo exhibition, Municipal Art Gallery, Jackson

1986 April 20—Wife (Celia Jane Oakley Hollingsworth) dies, Jackson

1987 Mississippi Museum of Art accessions 258 works of art by William R. Hollingsworth, Jr., into its permanent collection, from the bequest of Jane Oakley Hollingsworth

May 29–August 2—*A Retrospective: The Works of William R. Hollingsworth, Jr.*, Mississippi Museum of Art, Jackson

1998 *Art in Mississippi: 1720–1980*, written by Patti Carr Black is published (Jackson: University Press of Mississippi, 1998) (*It Was Cloudy When Evalina Married, Elevator, Tower Building*, and *Father and Child* are reproduced)

July 18–October 18—*William Hollingsworth: The Back Road Home*, Mississippi Museum of Art, Jackson

2000 April 26–May 1—*William Hollingsworth: My Mississippi*, Brookhaven Public Library, Mississippi Museum of Art Affiliate Network

May 2–21—*William Hollingsworth: My Mississippi*, McComb Public Library, Mississippi Museum of Art Affiliate Network

2001 January 9–February 24—*Hollingsworth and Hull: Watercolors from the Mississippi Museum of Art*, Greenville Arts Council, Mississippi Museum of Art Affiliate Network

August 11–September 30—*William Hollingsworth: My Mississippi*, Mississippi Museum of Art, Jackson

2002 January 12–March 10—*Hollingsworth and Hull*, Mississippi Museum of Art, Jackson

April—*Passionate Observer: Eudora Welty among Artists of the Thirties*, ed. René Paul Barilleaux, is published (Jackson: Mississippi Museum of Art, 2002 and 2003) (Untitled sketch of artist, probably Marie Hull, *Self-Portrait, Black and White, High Farish, Three in a Wagon*, and *Elevator, Tower Building*, are reproduced)

April—*On William Hollingsworth, Jr.*, by Eudora Welty, ed. Hunter Cole, is published (Jackson: University Press of Mississippi, 2002)

April 6–June 30—*Passionate Observer: Eudora Welty among Artists of the Thirties* exhibition at Mississippi Museum of Art, Jackson (seventeen works by Hollingsworth are included)

2003 *Passionate Observer: Eudora Welty among Artists of the Thirties* is presented at eight venues around the country, through 2007 (seven works by Hollingsworth are included)

2005 August 21–October 31—*William Hollingsworth: The Back Road Home*, Union County Historical Society, New Albany, Mississippi Museum of Art Affiliate Network

2007 *The Four Dog Blues Band, OR How Chester, Boy, Dog in the Fog, and Diva Took the Big City by Storm*, written by Lianne K. Takemori and illustrated by Maggie Dunlap, is published (Jackson: Mississippi Museum of Art). (*Billy and Boy* is reproduced. The character "Boy" in the story is based on Hollingsworth's pet dog, who appears in the painting.)

April 1–April 30—*William Hollingsworth: The Back Road Home*, McComb Public Library, Mississippi Museum of Art Affiliate Network

September 30–October 26—*William Hollingsworth: The Back Road Home*, Northwest Mississippi Community College, Senatobia, Mississippi Museum of Art Affiliate Network

June—*The Mississippi Story*, edited by Robin C. Dietrick, is published Jackson: Mississippi Museum of Art (*Elevator, Tower Building, Before the Sun, Black and White, Wet Hair, Christmas Eve*, and Jane Hollingsworth's *Showers with Winds Gusting Up to 40 M.P.H.* are reproduced)

June—*The Mississippi Story* permanent exhibition opens at the new Mississippi Museum of Art in the Mississippi Arts Pavilion, Jackson (fourteen works by Hollingsworth are included)

2008 July 8–August 24—*William Hollingsworth: The Back Road Home*, Crossroads Museum, Corinth, Mississippi Museum of Art Affiliate Network

December 1–31—*William Hollingsworth: The Back Road Home*, B. J. Chain Public Library, Olive Branch, Mississippi Museum of Art Affiliate Network

2012 September 22–January 13, 2013—*To Paint and Pray: The Art and Life of William R. Hollingsworth, Jr.*, Mississippi Museum of Art, Jackson

TIMELINE BIBLIOGRAPHY

Banner Herald. "Water Colors By Two Southern Artists On Exhibit In Fine Arts Building." May 11, 1941.

Barber, Bette. "Hollingsworth Display At Art Gallery." *Jackson Daily News*, September 7, 1939.

Bulliet, C. J. "Around the Galleries." *Chicago Daily News*, October 8, 1938.

Bryson, Frances. "Superb Watercolors, Prints, Oils, Etchings And Other Fine Works In New Delgado Show." *Sunday Times Tribune* (New Orleans), September 29, 1940.

Clarion-Ledger/Jackson Daily News. "Hollingsworth, Faulkners, Welty in Arts Festival Show." April 3, 1966.

–––. "Wm. Hollingsworth Exhibit Today at Millsaps Library." May 13, 1962.

Daily News, Moline (IL) *Dispatch.* "Water Colors by Husband of Local Girl at Gallery." n.d., 1938.

Dollarhide, Louis. "A Poetic, Loving Vision: Hollingsworth's South." *Clarion-Ledger/Jackson Daily News*, September 14, 1958.

–––. "New Officers of MAA; Hollingsworth at MC." *Clarion-Ledger/Jackson Daily News*, March 24, 1963.

–––. "Gulf Coast Art Fest Set February 10–15." *Clarion-Ledger/Jackson Daily News*, February 2, 1964.

Ellick, Catherine B. "Hollingsworth Show to Be Feature of Art Workshop." *Clarion-Ledger*, September 17, 1950.

Haggerty, Kay. "Hollingsworth Works Get First Public Showing." *Clarion-Ledger/Jackson Daily News*, January 16, 1966.

Hattiesburg (MS) *American,* "Hollingsworth Watercolors / Some of state's best art on display at USM." October 24, 1962.

Hawk, Eleanor. "Wm. Hollingsworth's Water Colors Hang At Conservatory." *Watchtower*, October 25, 1946.

Hollingsworth, Jane, ed. *Hollingsworth: The Man, the Artist, and His Work.* Jackson: University Press of Mississippi, 1981.

Hollingsworth (William) Photograph Collection. PI/2004.0020, folder 1, boxes 575–580. Mississippi Department of Archives and History, Jackson, Mississippi.

Hollingsworth (William) Press Books. Z/1242.000, boxes 1–3. Mississippi Department of Archives and History, Jackson, Mississippi.

Jackson Daily News. "Hollingsworth Exhibit Opens At Art Gallery." September 12, 1939.

–––. "Hollingsworth Painting Hung In California." September 26, 1939.

–––. "Hollingsworth to Head Art Department." September 5, 1941.

–––. "Hollingsworth Show Set; Mary Lewise Fletcher, Misses Ross to Entertain." October 11, 1942.

–––. "Hollingsworth Show to Be Opened Sunday Afternoon." September 7, 1949.

–––. "Hollingsworth Art In Vicksburg Show." March 18, 1962.

–––. Advertisement for Bryant Galleries, January 8, 1967.

Scott County News. "Hollingsworth Paintings On Exhibit Here." November 20, 1963.

Vicksburg Evening Post. "Artist Had Vicksburg Background." March 9, 1972.

Welty, Eudora. *On William Hollingsworth, Jr.* Jackson: University Press of Mississippi, 2002.